BEARDEN'S ODYSSEY

Poets Respond to the
Art of Romare Bearden

Edited by

Kwame Dawes and Matthew Shenoda

Foreword by

Derek Walcott

TRIQUARTERLY BOOKS / NORTHWESTERN UNIVERSITY PRESS

EVANSTON, ILLINOIS

TriQuarterly Books
Northwestern University Press
www.nupress.northwestern.edu

Printed in the United States of America

10 9 8 7 6 5 4 3 2 1

ISBN 978-0-8101-3489-8 (paper)
ISBN 978-0-8101-3494-2 (e-book)

Cataloging-in-Publication Data are available from the Library of Congress.

Contents

Foreword
Derek Walcott

There was a bellman called Charlie at the Chelsea Hotel in New York some-time around 1976–77. I was staying at the Chelsea, which is in downtown New York and was very popular with a certain kind of writer. It was recom-mended to me and I stayed there. Arthur Miller also stayed there. The host, the landlord, was very generous and considerate and very kind to artists. I was on a fellowship, so I wasn't broke exactly, but Stanley (Bard)—that was his name, and it's worth mentioning his name—was very kind and consid-erate as a proprietor.

Well Charlie, the bellman, saw me at the Chelsea, maybe coming or going, and he said, "Come, I have a surprise for you, come with me." So he did not tell me where he was taking me. He took me up a couple of flights, and he opened up a door to a room, and there were some other people there whose names I don't recall, but Romare was there. I had never met him. And Charlie said, "That is Romare Bearden." I forget the sequence of introductions, but I was astonished that it was Romare Bearden. It was Charlie who decided that I should know him. Well it turned out to be a great thing. Of course I knew his name, but I was very, very surprised, pleasantly surprised to meet him. Romare was a beautiful guy; very cour-teous, and considerate, very funny. I am always struck by just how much he was loved. It was his gentle, generous, and benign nature. But he saw a lot of evil, too.

He told me a story once about being on a schooner going from some-where to somewhere in the Caribbean, and the way he told that story—well, he could have published it, as it was punctuated with its rhythm of narration. He was one of the finest storytellers I had ever met in terms of the style, because it was as if he was dictating prose. It was wonderful. I got to know him very, very well, and he invited me down to his place in Saint Martin.

This is very corny. Romare was like a Buddha. He looked like the Bud-dha and he had these benign eyes and was concentrated in the same way as I imagine a Buddha must be. He was bald and he could pass for white, obviously. Of course he did mainly collages. I had the privilege in Saint

Martin of being with him when he was doing a watercolor, and the skill and discipline with which he worked was wonderful. He loved Saint Martin.

I believe Bearden was one of the greatest collagists America has produced, and he had a subject—namely, the "negro experience in America," out of which he was able to create work with a great narrative style. He created work from his own experience, beginning with his home county of Charlotte-Mecklenburg, in North Carolina. I was recently thinking about the cover art for my collection *The Star-Apple Kingdom*, a detail from a piece called *The Sea Nymph*, and I remember that when I got the cover, I gasped. He had this quality, this unique sense of proportion in his work. Sometimes the head would be larger or the hands would be larger than one would expect in representational proportions, but for some reason there appeared to be nothing untoward or inaccurate about his work. He managed a certain disproportion of scale that was wholly convincing; as if he was telling a story in terms of scale, and his proportions served the story.

His sense of narrative was not European, in this sense, but African, and he was developing a standard and a style that made him the leader of the tribe. He somehow managed to create his own reality, a reality that was compelling and true, such that his work was never exaggerated. This is a hell of an achievement.

Jacob Lawrence had some of this quality, but not as well defined as in Bearden, this narrative of proportion, which was achieved through balance. Here the fish is larger than the man, but perhaps the man is seeing the fish in this way, and in this remarkable way a narrative is created within the piece and the artist shifts the point of view of the subject.

Sometimes one is asked sardonically, "What is all this Greek stuff?" Bearden would have smiled at the question. In his work he was interested in going beneath the surface—a submarine figure. He was inventing collage techniques that he used as paths to narrative, as a kind of prose narrative. I have to be careful about saying this, but the narratives he created were not constructed in the poetic sense but in the prose sense, as a deliberate act of painting in the way that William Carlos Williams engaged prose in his poetry—an American thing. It was in his technical skill and precision. You see this in the work he did in that voodoo series. When he cut the cock, the rooster, the detail was astonishing, the delicacy of the narrative.

When people talk of the great American artists I am irritated that they hardly mention Bearden. His name should be called along with people like

Jackson Pollock—as he was clearly one of the greatest American artists of the twentieth century. And of course, he is left out because he was Black. We know that. It is the same way that Americans sometimes, when they are speaking of the greatest American dramatists, fail to mention August Wilson. To my mind, in both cases it is impossible to leave them out of that number of great American artists.

Introduction

I. Kwame Dawes

> Shuttles in the rocking loom of history,
> the dark ships move, the dark ships move,
> their bright ironical names
> like jests of kindness on a murderer's mouth;
>
> —ROBERT HAYDEN, "MIDDLE PASSAGE"

On August 26, 2012, I got one of Russell Goings's signature e-mails. Goings has a habit of writing only in the subject line of e-mails. The body of his e-mails is always empty. He does not sign out. His e-mails come in the style of telegraphs—brief, succinct, and typically filled with imperatives. "When are you coming to view Bearden up close . . . I have a scoop for you . . . My gift."

I believe I ended up in New York not long after that e-mail, largely to check out the work of Romare Bearden. I had been invited to the Brooklyn Book Festival, and I left the festival one afternoon and headed for Goings's apartment in Manhattan. I do not carry a mapping of the city in my head. I do know that the cab got me there, and I am sure that in the way of New York places, it is famous for its name—some number crossing some letter, that kind of thing. I got there. We walked through two rooms. The walls were covered with paintings and canvases, and framed paintings leaned against one another five or six deep. On a workman's table were piles of artwork. He knew where everything was. He started to lift pieces, set them aside, a flash of color, of sophisticated bold lines, of work carrying that sturdy assurance of great art. He was digging out the Bearden work. And as he showed me each piece by Bearden among work by Jacob Lawrence and a veritable gallery of great African American artists, he continued to tell me the stories about Bearden, their friendship, and his favorite, Bearden's love for the juice of collard greens sopped up by slices of bread. This amused Russ so much. The two had developed a strong relationship over the years,

and at some point Bearden did a line sketch of him titled simply *Russ*. This piece remains one of Goings's cherished gifts from Bearden.

Goings has a way of suggesting a certain profound understanding of the way the world works. He has a long history of being a mover and shaker in places where moving and shaking have massive financial consequences. In the past few years he has devoted himself to writing poems that are filled with wisdom and an urgent need to celebrate the deep Americanness of African American life and history. Every line reaches for song, for something archetypal. This poetry is collected in the beautifully designed epic poem *The Children of Children Keep Coming*, a work of rhythmical innovation and often brilliant explorations of the history and present of African American life. In it he is at once inventing form and yet locating his verse within a long tradition of speech making, sermon, and song in the African and African American tradition.

In person, he commands a room with silence and the occasional comment, thick with mystery and riddles, and then suddenly illuminating declaration. He drops small hints, and then looks at you as if failure to understand will be disappointing to him. But it is all given with a devious twinkle in his eyes, a kind of knowing sense that he understands that you get that he is messing with you. Goings's intelligence is large in the room—but then again, he is a big man who has done big things. "This is what," I thought, "an aging athlete looks like." He limps, slightly, and yet moves with unsteady grace. He is patient. He will drop a few words, look at you, waiting for you to say something. Much of what happens as conversation can be bewildering because everything seems like a riddle, and he knows the art of holding close to his chest every move. He chooses which questions to answer and which to avoid. The more direct the question, the more surreally inaccessible the answer. By the time I was to leave, we had talked for hours, and my head was full of great stories, and there was a tenderness and affection between us that he allowed to grow. Yet I left with only one solid piece of information. He wanted to do something with this art by Bearden. Wanted to find a way to celebrate Bearden's art. I quickly suggested something about ekphrasis—poets responding to this work. He did not agree to the idea immediately, but it was clear that he was not dismissing it.

By the time I was leaving, it was clearer to me that he had agreed that we do this book. My job was to find the poets. His job was to supply the art. The fact that I did not know at the time where the art in his apartment

came from, who owned it, what was to become of it, is classic Goings. Over the years he has survived and triumphed by managing information, giving only what has to be given and withholding that which does not have to be given to make the next move. When I asked the question directly, his answer was a genial look that said, "Are you really asking me that?" He expected me to trust him, and I trusted him. This was the beginning of this book. I would find out later that Russell Goings has been working on this idea, this idea of trying to find a way to combine poetry and this art, for a long time. For various reasons the project would fall through. He never said this to me then. But he trusted me to see this through.

It has been four years since that afternoon in New York. The idea became a genuine project fairly quickly. Once I invited Matthew Shenoda to work with me on this project, and once he agreed, I knew it was going to happen. The first task was to get word out to the poets about this artwork and this project. We discussed who should be in this book. I believe that Goings had mixed feelings about my conviction that this should be a book that featured the leading Black poets in America responding to the art of the great Romare Bearden. In a country in which this kind of calculated process of focusing on a certain group is seen as a limitation or even a diminishing of the value of the work, I could sense some anxiety about focusing on Black poets. But I had long been arguing that the roster was simply too impressive to even beg the question of quality and of the value of the project. In my mind, were I to say that I wanted to put together an all-star basketball team of Black players, I would likely be putting together the best team possible, with a few exceptions. My logic was straightforward, the matter of quality was not in question. The matter of historical importance was not in question. And finally, the rationale was clear enough to me: Bearden's art has been, for decades, inextricably linked to African American and Black diasporic poetry and literature. His paintings have been sought after for the book covers of numerous collections of poetry, and for a long stretch his art was on the cover of the plays of August Wilson. Bearden's modernity, the splendid meticulousness of his collages, and the lively suggestion of both fragmented memory and cultural wholeness made him exactly the poetic touchstone for so many African American poets. I felt strongly that in this instance, I wanted to see how reading Bearden as a Black artist could achieve what Langston Hughes tried to argue for in his essay "The Negro Artist and the Racial Mountain"—the possibilities, if you will, of evoking with full commitment and excellence the very Blackness, the very Africanness of an

artist in that deeply contextualized sense is one of the most reliable paths toward appreciating the universal power of that work. We wanted to create a room in which the "family" could express its appreciation for the genius of the artist who has shaped and influenced them.

The decision, also, to narrow down the Bearden work to the *Odyssey* sequence was guided primarily by Goings, who had conceptualized a way to curate some of the work he had of Bearden for a series of shows. He had an impressive collection of Bearden's *Odyssey* sequence as well as some important work in a series that celebrated African American "heroes"— paintings and sketches largely. In December 2012, just a few months after I first viewed the art, Goings's collection was featured at an event at the 92nd Street Y in Manhattan. A stellar group of thinkers and writers were invited to celebrate this work in a public event, which included people like Elizabeth Alexander, John Edgar Wideman, Stanley Crouch, and Goings himself. In the gallery, a convincing case was made by Goings's selection that an important conversation was taking place between the idea of African American heroism and the classic *Odyssey*. Themes of journey, tragedy, and triumph were all beautifully in dialogue with one another, somehow turning the *Odyssey* into something both archetypal and sharply specific. This interpretation of Bearden's work was central to how we conceived of this book. It allowed us to encourage the poets to engage a specific area of Bearden's oeuvre while never losing sight of the broader implications of Bearden's full body of work. We wrote to each poet. Our e-mails were never identical, but ultimately the thrust—the "ask" if you will—was the same. We wanted them to know why this project had come about and how we hoped it would work. There was a version of what is below in each of the letters that went out:

> Russell Goings, himself a poet of profound commitment and vision, has been, among some many notable things, the caretaker of the art of his dear friend, the late Romare Bearden. Some weeks ago, I visited Russ in New York and in the waning dusk, he showed me painting after stunning painting by Romare Bearden. Work that most of us have never seen. Some of his last startling works of masterly craft and uncanny candor and emotion. Soon that work will have its day, but in the buildup to this, Russ asked me what I would love to do. I told him I would like to ask the poets I admire and respect in this country—African American poets—to write poems responding

to this great art, poems that will be collected in a publication, an anthology featuring prints of this art.

Here are some of the titles of some of these images (some Bearden fans may recognize these):

Circe's Domain
Conjure Woman
DS [Death Series]
Harriet Tubman with Gun
Odysseus
Realm of the Shades
Russ
Siren Song

He said he would grant permission for the publication of the art.
So now I come to you.
I would like to give you access to these images, and then leave it to you to respond with a poem. The project, then, is simple.
Are you interested?

They were. It is clear that I did not quite know how much of a "day" this work had already had. This, of course, ended as the letters came pouring in, quickly, and filled with great enthusiasm. We opened up a Google Docs account with the images so that folks could view the work. The reproductions were not brilliant—some of them were from iPhone photos I had taken of the works on display at the gallery at the 92nd Street Y. But the works are available online as Bearden's *Odyssey* series makes an appearance in numerous prominent and private collections around the country.

The poets did not need much convincing. Of course, the greater challenge was to determine whom to approach. Given the incredible explosion of African American poetry in the past two decades, and especially in the past few years, the emergence of some "stars" in the poetry scene, we had to agree to a principle of inviting "senior" or established poets first. There is some subjectivity in this process, of course, and it is probably best to consider it as a process of inclusion rather than a process of exclusion, as much as this is possible to do. The response was speedy and refreshingly positive. An extremely small number of those we approached said no. Some said they did not do this kind of thing but would do it because of how they felt about Bearden's work.

We knew immediately that we were witnessing the making of a truly beautiful gathering of some extremely delightful poetry that rose to the challenge of matching, or at least complementing, the genius of Bearden's *Odyssey* sequence. It really did not take us long to pull together a working manuscript. Matthew and I spent a long time thinking and talking about whom to approach with this project. We had considered the kind of project that would be published by a gallery, but the implication would be that the artwork would be the center of things, the engine for it. In many ways, while this was an attractive idea, we also knew that there existed several books devoted to Bearden's art, including the work from the *Odyssey*. We also felt that the unique value of this project was the new work—the poetry that was being written for the express purpose of celebrating Bearden's art. More crassly put, we knew, given the names of the poets already agreeing to be involved, that we had in hand an unusually remarkable anthology of African American verse that could be credibly published with or without the artwork. I should explain that this fact filled us with a great deal of confidence because we live in a world in which poetry books are not immediately seen as self-justifying works. One has to truly sell a collection to most publishers, and often when they do agree to publish, they make it clear that they are embarked on a venture of subsidizing art. The thought of having to include prints of the art of one of the greatest of American artists would make any publisher nervous when it comes to permissions, managing the copyright issues, and the costs of production of such a book. Matthew and I agreed that even if we did not have the artwork, we would have an amazing book. But since we had the artwork, the key was to find a home for the work.

Our discussions spilled into the spring of 2013, and during the Association of Writers and Writing Programs (AWP) Conference that year, we decided to pitch the project to Parneshia Jones at Northwestern University Press, who had recently published Matthew's latest book of poems and with whom we had been having exciting discussions about the way she was building an impressive list at her press. At breakfast on one of the AWP Conference days, we discussed the project, and she was enthusiastic about it. We decided to look no further. This relationship has proven to be one of the most important aspects of this project. Parneshia and her team have been fully invested in making this book a reality, and there is something especially reassuring when someone like Parneshia is at the helm.

Eventually, we decided to treat the book not as one in which the artwork

and the poems stand as parallels to each other—the poems "interpreting" the artwork—but as a gallery of art and poetry that celebrates Bearden and his wider work around the theme of the *Odyssey*. This has ensured that one can read this book as a splendid and innovative collection of contemporary Black poetry and as a fascinating exploration of the dialogue that can happen between art and poetry. Given the number of poets featured, and the number of poems featured, it should be clear that the artwork published here is not an exhaustive look at the Bearden series but a representation of some of his more interesting work within a certain period of his career.

At a time when African American poets are reshaping American poetry in remarkable ways, and at a time when there is a tremendous depth and complexity to the work that is being published by Black poets in the United States, this anthology offers a platform for some of our gifted artists to use their poetry to position Bearden as a genuine American genius in very much the way that Derek Walcott, in his generous and pointed foreword, does.

II. Matthew Shenoda

When Kwame first called me and said, "Shenoda, I have a project I'm thinking about," something in my head said yes, before I even knew what it was. Then as he began to speak, the gathering of words—Romare Bearden, art, Odysseus, poetry, legacy, Black poetics—quickly came together and piqued my enthusiasm. I committed on the spot.

The thing is this: for some time Kwame and I have been engaged in often very lengthy conversations about the impact of African diasporic poetics on contemporary poetry, and I saw here an incredible opportunity to curate something that would showcase the breadth and strength of what we have been discussing all this time. We began almost immediately to assemble the names of poets, talking about each one and their aesthetic contributions, what we knew they could bring to such a project. The list grew unwieldy, and soon we were dealing with an overabundance of talent. We knew we could never include them all into a single book and so began to create a loose rubric. We would invite poets who generally had at least a couple of books in the world, who had made a name for themselves in the various schools of poetics that pepper our landscape, who write from varying positions, and who, most importantly, would approach Bearden with fresh

eyes, who would understand something of his impact and the way it informed their own work.

We wanted those who would see this as a way of engaging a sense of legacy. We wanted the gathering to be intergenerational, to work across genders and aesthetics and to show what some of the freshest contemporary poets were up to. What you have before you is nothing short of these goals, each of these poets taking on specific elements of Bearden's work as an integrative influence to their own medium in the celebration of this great artist through language. The ekphrastic impulse is clear, but what is even clearer is the seamless manner in which the visual and the oral can converge, the way the poet, perhaps unlike the critic or other writers, can embody the visual elements of the work and give them breath.

But what is perhaps even more significant here than simply the celebration of Bearden's work is the masterful example of an artistic community that coalesces around a common point of inspiration. Few artists can so effortlessly bring together such a willing gathering of fellow artists. And as a result, what is included here is a sample of some of the best poets writing in America. Not the best African or African American poets, but the best poets, period. It happens they come from the African diaspora, though we know well it doesn't "happen" at all. Their immense abilities are a direct result of their antecedents and their diligence, their urgency and their discipline. That is what makes them the kinds of writers they are, and as editors we are unwavering and unapologetic about that fact.

You see, Kwame and I are people who have always believed that every tree stays up by its roots, and what you will witness in the pages of this anthology are deeply rooted works that bud and flower in nearly miraculous ways. I am reminded here of the story of the Egyptian desert father who told his young disciple to thrust a small stick into the ground and water it each day. The disciple did so, for years and years; so long, in fact, that his elder had completely forgotten what he'd asked him to do, until one day, as they walked together through the desert and the elder said, "Where did that glorious tree come from? I've never seen it before." His disciple reminded him of what he'd asked of him all those years ago, and the elder quickly gathered the fruits of the tree and called all the community together to share in the bounty of this discipline. The poets gathered here have each taken on their own stick to water, have each diligently carried their buckets day after day in hopes to see their efforts take root. Each of them has achieved this, and together they create nothing short of a bountiful harvest

that has rooted itself in the works of Romare Bearden. This is a celebration and continuation of Bearden's legacy, a man who himself never veered too far from poetry.

Among these poems, you will find some works that reference specific Bearden pieces included in this book, some pieces that reference works that were part of our original call but not included here—pieces like Bearden's sketch of Harriet Tubman that E. Ethelbert Miller renders timeless in his beautiful small poem "Tubman," and pieces that speak to the overarching ethos of Bearden's work from this period and others. Poems like Quincy Troupe's "Romare Bearden's Art between 1964 & 1985" that take the reader on a journey through two of the most prolific decades of Bearden's life.

You will also find work that speaks to Bearden's own life circumstances as an African American artist working in an era of immense social change. As A. Van Jordan writes,

> he was in a land adorned with flames
>
> but a land still green with possibility,
> bustling with shadows of fallen men.

Jordan speaks here to the ways in which Bearden created possibility even while grappling with the most troubling of times both historically and in contemporary life. Some have explored the more introverted contemplations of how the art and person of Bearden collide into a kind of personal transformation. As Yusef Komunyakaa muses,

> Sometimes a man goes inside himself
> & rises in a damp sunny new land.

Or as Evie Shockley writes in an exploration of Bearden's own personal migration from South to North,

> gonna
> put long uneasy miles between me and my home, but it's not
> a one-way ticket this here's *circe's domain*—come on in and set a
> spell hey, wanderer the north's no escape, just another stop
> *on some lonesome railroad line.*

Yet many of the poems included here dive directly into the subject and visual arrangements of the pieces themselves. Poems like Marilyn Nelson's, where she writes,

> Maidens hundreds of hues of brown offered
> trays of their food: a flower called lotus,
> that satisfies, yet increases hunger.
> I sat down, asked myself why I should starve.

Here Nelson's poem delves into the subjects of Bearden's work and breathes life into the two-dimensional depictions in his piece *The Lotus Eaters*, the persona of the subject often mingling with the voice of the poet. Or as Rita Dove's poem takes on the haunting conjure images Bearden's work so expertly represents, coaxing the reader and viewer,

> See that lady in the clown suit
> just outside your field of vision,
> watching from the forest's green edge?

That sense of watching, of the artwork looking back at you, is ever present in Bearden's work and deeply familiar. Expanding on this notion, on the ways in which the history of Bearden's subject, which is the history of Bearden himself and of so many of the writers included here, builds layer by layer to create both a visual and linguistic collage, Ed Roberson takes this sentiment and beautifully frames it in the lines,

> Generations of features average to mask,
> face whose any expression is recognizably
> family almost by name pasted any
>
> size sunk small from close to far time or cut out
> brought closer than face to face, lined internal.

And Patricia Smith, playing further with this notion of family and directly off Bearden's images, illuminates the emotional weight of the transatlantic slave trade when she writes,

My brother asks permission to spit his blood into the dust. Hearing its cue, our one heart begins its runaway beat, its show for the nice people. They clap crazily, the bidding roars. The heart is the first thing sold.

Here we are reminded of how the horrors of slavery created that bond of the "one heart" that Bearden, Smith, and countless others still share today.

These are of course just brief samplings of the immensely rich and wide-ranging poems found in the pages of this anthology. A celebration and a testament, an exploration and an archive, a snaking continuum that reframes each generation past, resurrects collective memory, and establishes our present moment more relevant than we often care to admit. And I can think of no more fitting way to illuminate this relevance and formally usher in this book than with the words of the masterful poet Lucille Clifton, who if alive today would no doubt have contributed to this gathering of poets and whose seminal poem "won't you celebrate with me" speaks clearly about the legacies enshrined in these pages. Join us in this celebration of Romare Bearden, in this celebration of an unending inheritance:

won't you celebrate with me
what i have shaped into
a kind of life? i had no model.
born in babylon
both nonwhite and woman
what did i see to be except myself?
i made it up
here on this bridge between
starshine and clay,
my one hand holding tight
my other hand; come celebrate
with me that everyday
something has tried to kill me
and has failed.

BEARDEN'S ODYSSEY

Fire Psalm

Chris Abani

I

The lift of albatross.
The riddle of iron
Ember.

My prayers have changed with time.
Now I want it all, O lord, the depths
And the heights. My heart is a fire.
Psalm that cannot be extinguished.
I am the miracle of oil.
Even when the light leaves and feral night settles
I know I cannot be extinguished
Even as you make me wood for your fire
Even as my eyes burn from the smoke of insight *Cyclops*
Even as terror fills me sometimes I know
You are consuming yourself in your rage
But I remain, a relentless shadow

II

The resistance of stages.
The body in dance.
Stone. Ember.

What does it mean, an ordinary life?
As if there can be a lesson in the fall
of browning leaves. But I am dreaming.
What can it augur to feel that only a crow
on a wire can understand me?
Somewhere, out there, a woman grinds cornmeal.

A monk taps sand into another mandala.
The grain of puzzle, the rub of mystery.
Testament. Already the word is a betrayal.
An incandescence replaced by a matchbook.
A kid stiff in khakis told me about war.
There is no legend to it, he said. No journey. You just pull
the hammer back and casually metal shrugs
against metal and you shoot another man in the sand.
Poetry is the husbandry of memory, yet one
to attempt a feast in the future; a fingerprint—
trace. To say good morning is such a sweet torture,
as my fingers hover over a phone. Instead I make toast.
Each bite vengeful. Each knife scrape of butter deliberate.
To sink my fingers into the wet earth. Root
around the slip of worms, dig, turn over clods.
I learn soon enough that every flower bed
is a grave, every ripe tomato the pendulous
weight of death. Water I hope will save us

III

The destiny of rain.
The slap of water on wood.
Stone.

Do you remember when I first tried to leave you?
In that dusty red-soiled town, our old house
leaning into the rusty barbed wire fence of the seminary?
Begged you to let me go? You smiled. Cruel. Said:
I'm not done with you yet. If you leave me
I'll have you deported. And so I stayed.
No woman can leave five children like a wayward past.
No road can hold that journey. Tonight my son washes my feet,
towel dabbing blood from the cut that opens every day
like a flower, compelled by the crack in the heel
of my wooden clogs, a straight line.

Why do you wear these if they hurt you, he asks.
How can I tell him that this wound is all that
keeps me from killing his father. And even in this
he is learning that hate begets hate,
but sometimes limned by love. Amen.

Homily

Chris Abani

What does it mean, an ordinary life?
As if there can be a lesson in the fall
of browning leaves. But I am dreaming.
What can it mean to feel that only a crow
on a wire can understand me?
Somewhere, out there, a woman grinds cornmeal.
A monk taps sand into another mandala.
The grain of puzzle, the rub of mystery.
Testament. Already the word is a betrayal.
An incandescence replaced by a matchbook.
A kid stiff in khakis told me about war.
There is no legend to it, he said. No journey. You just pull
the hammer back and casually metal shrugs
against metal and you shoot another man in the sand.
Poetry is the husbandry of memory, yet one
to attempt a feast in the future; a fingerprint—
trace. To say good morning is such a sweet torture,
as my fingers hover over a phone. Instead I make toast.
Each bite vengeful. Each knife scrape of butter deliberate.
To sink my fingers into the wet earth. Root
around the slip of worms, dig, turn over clods.
I learn soon enough that every flower bed
is a grave, every ripe tomato the pendulous
weight of death. Water I hope will save us

From Omni—Albert Murray

Elizabeth Alexander

BEARDEN AT WORK

> Regardless of how good you might be at
> whatever else you did, you also had to get with
> the music.
>
> —ROMARE BEARDEN

Paper-cutting rhythm, snips of blue foil
falling onto water-colored paper,
colored people into place. Eye divines
arrangement, hands slide shifting paper shapes.
Panes of color learned from stained-glass windows,
pauses spacing rests from Fatha Hines.

Odysseus is blue. He can't get home.
In Bearden's planes: collage on board, shellac.
Watch Dorothy, children, enter Oz.
Look, Daddy, color! No more white and black.
This is the year of the color TV.
Odysseus is blue and now is black.

New York City at Christmastime. Christmas
tree—shapes like Bearden in a Bearden blue.
Tin stars falling on a yellow paper
trumpet. Blue sucked in, blues blown back out.
Black folks on ice skates shine like Christmas trees.
New York glitters like a new idea.

A Siren Patch of Indigo

Cyrus Cassells

Listen: though we swell as rampant
woodland or riverbank blossoms

(*Baptisia australis*)
in your tensile world,

as commonplace beauty
& reachable remedy,

as soothing eyewash for the Osage,
hardy dye for the Cherokee,

quiet as it's kept,
we're more akin to

clearing & hillside way-showers,
offhand griots quietly reminding you

the punishing rows, the grim
nightworld of the Middle Passage

was never your true province;
even in appalling chains,

the light of your integrity,
your inmost wonder

still encircled you,
resolute, inviolate.

Always recall, dear
progeny of Sea Island slaves,

in galling dearth
or in Juneteenth glory,

our deep, annealing, sacramental blue
belongs to you.

The Sirens' Song, by Romare Bearden

Fred D'Aguiar

Nikki's in the picture as I stand beside her
In the museum down the road from Maya's place
And see us two reflected in the glass over the frame
Or in the lights bouncing off the "big men's colors"
Of the rendition of Odysseus bypassing a port.

The black stick figures chiaroscuro à la L. S. Lowry
Except for the heraldic in the ordinary of black folk's
Extraordinary heraldry, our hero lashed to the mainmast
Sees and hears all and can do nothing about any of it
While his deafened crew rows away from temptation.

That is the story of our history if truth be told,
That we live and take struggle in our stride,
That the color of our lives may pass us by
If we obey forces besides love because want
Is our only compass and love our constant loss.

NOTE: "Big men's colors" is how Bearden described the
bold colors of his paintings.

10

Forest

Kwame Dawes

after Bearden, Odysseus Leaves Circe

1

It is not hard to imagine the lure of youth,
the heavy defiance of breasts, as if planted
there, the smooth innocence of sparse growth
over her curved belly; the back slanted
just so, and the casual bounce of her ass;
a man's palms long for the push back
of flesh, the easy journey down her flank,
the laughter, the surprise of her slack
weight; things she knows; she even thanks
him afterwards. She, the usurper of all
I have; she, the fertile ground, where seeds
sprout wildly, she of giggles, the spoiler,
the one who understands her power
that tight pussy smooth faced overthrower.

2

You know she is sweet as a daughter,
you know when her periods come she cries,
curls up and asks him to come cover
her with blankets and collect her soft sighs;
you know she fixes him meals she knows
his mother used to make; makes him eat
while she looks at him smiling, you know
she smashes plates, crosses her chest, beats
him with her fists, letting him hold her back,
laughing at her flame, and she falls
into his arms, weeping; so he smacks
her ass; tells her to hush soft-soft, all
tender, till she calls him, "Big Daddy Troy."
She opens to him, giggling, "Come, Big Boy."

3

You loved me most when I was swollen
with this boy when I was a waddler,
when my stomach churned, my body stolen
by him, when I was so fat. Under
all that water and flesh; you loved me,
man. Before you left, you'd be rubbing
hands on my back till a slippery
finger tested my wet; you used to sing
to me, pushing in so slow, asking,
"You okay? You okay?" And how tender
you were holding yourself back, humming
until I shuddered onto you, remember?
You loved me then like a gardener
of delicate things, my sweet, sweet lover.

4

When a man says his sin is his life,
and though caught, he won't let go
of the bitch; when he says to his wife
he wants to stay, but she has to know
that he will continue to go to the girl
out at sea, and pay for her panties,
and eat her food, what in the world
is a woman to do? She will try pleas
for love, loyalty, decency, but soon
she will grow a stone in her belly,
and a callus over her heart, then bloom
bitterness so thick and smelly,
to darken and stink up this nest.
She will soon become a deep forest.

Cyclops I

Toi Derricotte

What crown holds
A howling baby,

A warrior's shield,
A clown's hat,

A naked man
Walking into his own grave,

3 small explosions
From a child's party favor,

And the leash of a bad dog?

What face
Has a uvula

For an eye,
A mask like a lynx,

A nose fat as a prizefighter's?

What man
In hanging earrings

In charge, what raging
Sorrow did I meet?

Cyclops II

Toi Derricotte

Would I fear
The one who sees me

With one eye missing?
The king of broken teeth

Rules over a poor kingdom.
His crown is a howling

Baby, his whiskers of ice.
Will he, both hands raised,

Kill me
Or bow down?

Conjure

Rita Dove

So many things we traffic in without knowing how.
Not to mention why, forget why for now:
The trick is to concentrate sideways—
off-site, so to speak, sliding your eye as far
as it will go in order to glimpse

the thief escaping on silken legs.
Text, twitter, copy, share—all in a day's
busywork, the long glazed frenzy,
and before you can turn around
it's vanished, poof! Time's up.

Who saw that skull coming?
Which bird, black or white?
Ditto the snake;
what creamy rope
did he slide in on?

This is some serious shit,
no time for monkey thumbs
OMG Ull never guess what happened 2 me!
As if life was a series of Never Minds
skipping stones downstream,

a hop-scotch from one wiki-square to the next.
See that lady in the clown suit
just outside your field of vision,
watching from the forest's green edge?
Delete, reboot! (Don't look: The cloud's still there.)

Cove Song

Camille T. Dungy

One and two and three: in time,
 white birds hum out of the choir
of air, while we tend our dark skin
 with coconut oil, content to sing
a welcome to the high and low tides.

 The sky song is a blues the sea
comes into on repeated lines. Why, even
 the rocks sing, and the reeds. This
is how we learn what game to lure
 into what traps, which scales
to seek, which to keep at bay. We've heard
 the mess those men have said. That
all we do is stand around and chatter.
 It drives them mad, our simple acts
repeated for the pure pleasure of sound.

 We've taught the flowers, high
and yellow, how to modulate
 their tone. They used to come off sharp
and off-beat, but now they blend
 right in. The men think themselves
industrious. Sword thrusting,
 sea sailing: the purposes of their purpose
driven lives. It makes them crazy
 to think we do nothing more than play
the lyre, sing all day. Like a group
 of grade school boys trounced in debate,
they plug their ears and turn away.

Only one climbed the lookout
to listen. Does he hear? Even
 the boulders' jaws are wide,
even the canoe's mouth joins our song.
 The cloud is singing softly. Listen now,
her voice will blend with wind, with rain.

Circe after the Feast of Kine

Vievee Francis

after Bearden, Cattle of Apollo

Just like ~~Eurylochus~~ who didn't give a fuck
what ~~Odysseus~~ thought, who doesn't have a lesser friend
whispering that bullshit into your ear. If O wouldn't hear it
someone else would. You know the type of friend I mean
(if you're honest): ~~half your vision~~, twice the hype,
and sometimes the wack gets through, and you lose
the woman you loved or the man you loved or both,
point being—~~there is always someone willing to wrest~~
~~what's yours especially if you have more than they~~
~~could possibly hold.~~ You hear me don't you? The waves
aren't banging the shore too loudly are they? I wanted
to make this a statement on Beauty, how beauteous
the bovines on the hillock near the sea, how ample,
but this is a warning. I am suggesting Sweet Sojourner
you take heed. Having escaped once, bound to the mast,
doesn't mean you won't be roped again. But not for those
sirens, wide-hipped and gleaming as the Cattle of Apollo,
their own lows enticing you over the ululations of the swells,
no, nothing that divine. Next time
you too will feel the overheated tongue of a friend in your ear,
someone you thought you could trust, waiting until you go
up the mountain to think, to get your head together,
who will then turn to the rest, followers all, and betray you,
putting the innocent to the spit, knowing *just* what it will do
to you who wanted only to be liked, and so could not see
through the one who wanted only to be you.

Poseidon Hears His Baby Boy Crying

Nikki Giovanni

It hurts, Daddy

That man who came

To play with me

He hurt

I didn't mean

For the men to go

They were fun

They crawled around

The sheep

And I found them

And laughed and laughed

But they broke

And they cried

I wanted to hold

Them

To see what they tasted

Like

Remember the Ginger

Bread men

Remember the Chocolate

Men

Why did the White

Men

Break

Then No-Man got mad

And hurt me

I can't see

Daddy

My head hurts a lot

Why did No-Man take

My eye

I only wanted to play

With him

~~Is he broken~~

~~Too~~

I'm sorry, Daddy

I'm sorry I can't

See

Make him give it back

Daddy

Make him give it back

Circe to Her Mother

Aracelis Girmay

Misunderstood. What I was trying to reach
was you. Where I was raised,

always, the long dash of horse hair
hanging from the wall, to swat

flies. Frankincense burning
in the coffee room. Boon.

Back home, we lived
with the animals. But the grayness

of their eyes in death, not just
their lives. It was love

for home and for you, Mother,
who caused me this sorcery.

Before marriage, there were some horses
I knew, and hills. I did not want to go

from there, from where
we were two-headed once, and then

the great wound of birth, an I—
by which my seeing is Forever Red.

I wanted you to, Mother,
never let me free. I am home again,

if I lay on my side beside
the sleeping wolves, once men—

how like the hills of my childhood.
White with snow and brown with the names of trees.

Como te lo puedo decir? "Leaving" was full of salt, was
not my verb. Now I cannot bear a kingdom of free things.

after Circe's Domain

O

Aracelis Girmay

I.

from the future, eight sirens heckle Odysseus, heckle rOmare

your lungs full of air, your

 sailors full of wax, your lack

of will, then your will, your

 hearing, the white froth

of gull, salt lapping at

 the boat's brown skin,

the strange syntax of

 your body's phrasing, perpetual

blues, the perpetual blue

 through which we read

your diss, dis-

 ease, aster &

"discovery" of, our

 goat-eyed vision, our

vision Legba, & Janus, how

 Janus-vision, now, is

raiding you, you rascal made

 dizzy by the sound of krar. Our

Future-eye sees: your body is

 a black flag wounding

the pastoral scene, scene

 phrased by anguish. The greenness of

our mind taunts Ship

 to which you thrash. Our song

does two things: Calls

 you by your old name back

into the dark rock

 of your death & means

to crash the fleet, revise the birth

 of that terror-industry

by which you, rOmare, & we.

II.

the poet as ventriloquist

Claim, I, to be the poet, making talk
the sirens who foreground the scene

where even the sky sings *Romare, Romare*
whose body is a mourning sound

(blood hyphened by the fleet
to Saint-Domingue, to Rome), is

siren speech. But listen closely.
It is *my* mouth wailing redly

into the scene from The Future Knows.
It is my history raiding me. Romare,

teach me how to read this blues, please,
differently. How not to

assign all blackness near the sea
a captivity. I, the descendant

of each early war, who cannot remember peace,
have taken hostage the greenness

of my own mind. Want
the sirens to be

only the sirens. The sea
to be only the sea. O, magnolia

without blood, blackness
without blood.

 after The Sirens' Song

Bearden's Scylla and Charybdis Is a Picture

Terrance Hayes

of shipwrecked souls foreshadowing
the souls of bold Katrina declaring:
"Fuck today, fuck tomorrow, where were you
yesterday," to an American god and government.

I look down into the sea and see the people
who tried sleeping in blankets of clouded
water and woke in the bodies of mythic fish.
I must teach my child to swim. I woke
just morning raw as a whale's tongue,

and because I did not know whether
the day would lean nearer to Scylla
or Charybdis, began to calculate reasons

to breathe. Initially, no one grasped
the dangers of water. The beaten sky
might look like mist, steam, vapor raging
in a loose and illusory weather, to some

it might seem disastrous to be asylumed
between the sea and the devil's parlor,

but this picture shows us how the blues
were represented before darksome mouths
began to belt survival chords.

My painter is suffering a notion of color.
It is a picture of how not to disappear
completely between the anchor and the oar.

In a far harbor the wives in blue scarves
grow darker going darkly about the tasks
that should be a husband's business.

The heart needs something, the dirt
needs something, the children need
something, the Lord needs something
to live. A mind charting what to love

not what to comprehend knows the best course
between Scylla and Charybdis, history
and hysterics. When I saw your painting,

Mr. Bearden, I was transported
the same distance as manhandled shipments
lost between troubled waters and the Africans
awaiting our return raising fire on the shore.

There are white people determined to make me
hate them, Sir, but I have refused thus far.

for Kwame Dawes

Calypso's Magical Garden

Major Jackson

It's bad when a man doesn't
own even his dreams, a faint
head full of the scent
of a woman, her special claims

and beguiling herbs arched
in the crevices of his ears
like plugs of gold, his scorched
mind far from wife & kids, tears

turning his eyes to pebbles
splashed by briny waves.
Possessing no firm farewell,
she makes his sex a slave.

No will in her cavern,
no choice to rise up a god,
free of the banal pattern:
no leaving her roughshod,

her chocolates scattered,
clutching ardent notes.
Instead, on the immortal ladder
of her limbs, he climbs & dotes:

her braided hair, her bangled
wrists, the garden's chimes,
their afternoon mangled
in bits and chunks of time.

Even the birds, stilled to a silence
by the unannounced show, a man
wearing the crown of the island
until she lets him go.

root worker {middle passage} marabout

Honorée Fanonne Jeffers

after Bearden, Conjur Woman

when the moon is on you
lift your big hand

don't walk in corn
before you speak

don't talk visions
stand at watery roads

zigzagging faith
path for dead kin

preacher woman
marabout conjure root

step in sanctity
on holy names

ride on ride on
her blood the living

write down this the atlantic
awoken after triangles

insanity love
second God's breath

blessed timbre blues
voices calling woman

spit out the story
i am grateful

quilted dress of hoodoo
i am faithful

green aired medicine
make me human

black gris-gris bird
two tangled roads

misery joy the load
spirit lived strings

kaffir line
small anger ecstasy

pray now pray
lost birth name

the sea the remains

The Taste of the Lotus (London, January 4, 2013)

Honorée Fanonne Jeffers

after Bearden, Land of the Lotus Eaters

Darling, at first we did not know why the white men
came for our brothers. And by the time
we found out, it was too late.

—IDRISSA

It was an outlander's honeymoon:
London at Christmas failed to impress
my African Muslim husband.

A trip to the Slave Trade Exhibit
at the museum didn't change his mind.

I was outnumbered in a house
with three Senegalese, an Ivorian,
and a hostile, polyglot toddler.

I debated in whispers,
afraid to wake the Diaspora:

*Stop making your excuses
for those Africans*, I said.
They certainly did *know what slavery was about.*

Yet I'd fallen in love with Senegal,
a country brutally dear.

The sea sought to drag me down one day.
I had to run away from the water,
find the inconstancy of sand.

No, we didn't *know*, my husband told me,
at first angry, then patiently convinced.

And anyway, it's not those Africans *anymore.*
It's us Africans, *because now, you are my wife.*
In London,

I'd chop onions for my inferior Jolof rice—
and then, a memory of just-torn

mangoes bought from ladies
on the road north to Dakar:
that candied funk I craved.

Bananas shamelessly cheap.
Milky sap of the baobab, addictive in the glass.

Which one of these tasted of the lotus,
that mythological, apathetic fruit?
Pacified African traders as they waved

good-bye to the ships and their
close-packed, murmuring kin?

red {middle passage} path

Honorée Fanonne Jeffers

after Bearden, DS (Death Series)*, and Sonia Sanchez*

I baptize thee in the name of Our Lord Jesus Christ

hunh hunh hunh hunh hah hah hah hah
hunh hunh hunh hah hah hah man man man man
maaaaaaan take off my mask hunh hunh hunh
hah hah hah maaaaaaaaaaaaan take off my mask
hunh hunh hunh hunh let me see hunh hunh hunh
let me see hah hah hah hah maaaaaaaaaaaaaaan
man hunh hunh hunh hunh look at me
look at me don't don't red red red red red man man man man
square toe toe toe toe man hunh hunh hunh that mask
maaaaaaaan mask maaaaaaan square toe hunh hunh
man man man man man man man man maaaaaaaan
i see you now i see you think i don't see i see see
see see see see seeeeeeeeeeeeeeeeeeeeeeeeeeeeeeeeeeeeee me now
now now now now don't look at me what i see what
don't nooooooooooooooo don't what know
nooooooo now now now now now hunh hunh
hunh hunh hunh hah hah hah hah hah hah
hah hah hah hah hah hah hah hah hah hah
hah hah hah hah what what hah hah hah hah hah
hah hah hah hah hah hah hah hah see
see see see see see red red red red red see see see see see
see man man man man what man hunh hunh
hunh hunh hunh hunh hunh hunh hunh
no oh oh oh oh oh oh ppppppppppppppppppppppath
see see see see see see see see see see see that red
red red red red red red ppppppppppppppppppppath

hah hah hah hah hah hah
hunh hunh
 hunh

pppppppppaaaaaaaaaaaaaaaaathhhhhhhh

TO BE SOLD: A parcel of likely Negroes imported from Africa

Blues: How Many Sat Underwater

Honorée Fanonne Jeffers

after Bearden, The Sea Nymph

How many sat underwater,
entangled by myth's past tense,
before Odysseus, always living,
was saved by Homer's tablet?
And centuries after that story was written,
in the land of Not Make Believe,
a crew of slave-ship sailors
threw one hundred and thirty-two
Africans into the Atlantic Ocean.
Heave-ho to souls.
And people. And laws. And kin.
But Odysseus lives. He always will,
Our Great White Hope—
before whiteness was invented—
this hero who longs for the wood's sway.
Despite his tendency to chase tail—
sirens and sundry other
poppycock-swallowing girls—
I want to be happy that Homer imagined
a sea housing pretty, forgiving Nymphs—
while somewhere else, a wheel dances
and someone else drowns.
Sharks should pass Odysseus by,
never imagining his taste.
The gods shouldn't pull at his fate—
now angry, now benevolent.
I try hard not to blame that man.
We all deserve our maker's love.

Bearden's *Realm of Shades*

A. Van Jordan

To hold on to the memories of home,
the haunting memories,

the ones that came to him even as a child,
before there were memories to forget,

Odysseus would *try* to forget their omen
of violence, poverty, and unemployment

before they took root within him;
he set sail for lands unknown,

leaving home in his mind, dreaming,
knowing there was more beyond

his country's border, he struggled
to come back to himself

and to others he loved.
Once he reached the water,

the water reached back;
he struggled over the waves,

realizing, finally, these waves
he fought were the waves he created;

they built within him as he struggled
to tamp down himself all while finding

the man dreaming at sea, finding
in his dream a boy who was himself,

dreaming of this moment at sea.
How does one find the courage

to be one's self, even in a dream?
He rode the waves, accepting their fate.

At dawn, the next day, Odysseus
roused to find that he wasn't in Ithaca,

not back home in bed with his Penelope;
he was in a land adorned with flames

but a land still green with possibility,
bustling with shadows of fallen men,

fallen women & children,
a land filled with the knowledge

of the past and of the future.
Like most depressed neighborhoods

there was an old man sitting
in the center of downtown,

casting knowledge. Odysseus listened; he got it.
Odysseus took the tribal mask of the forgotten,

a shield from a man wounded in battle, a spear
from another who missed his mark, and this old

man's new knowledge, which made all new,
and he walked the streets of shadows

like the big man he dreamed he would be,
and there on the horizon like in the dream

of far away lands he had as a boy, was his home.
But after ten years away, what was home to him?

Love. One might say it fueled his journey.
Who survives any world without someone

with whom to share a bed or a bottle of wine?
Who wants to?

Nothing heroic needs to occur to know
you're alive; another foot brushes your foot

beneath a sheet in the middle of the night,
and one can live for years on this alone.

As long as he was away from this,
he was on a journey. A harsh road

wends toward a couple's bed. He remembers
taking her by the waist, pulling her in close,

he believed he'd always come back to this moment.
But he knew the risk and promised (more

to himself than to her) that he would return.
He knew his returning—no matter the suitors

in between, no matter the witches or sirens
taking him off course, even the *desire* to return

when staying away is easier—
would say more about his need for her

than if he had never left her at all.

Roamer

Douglas Kearney

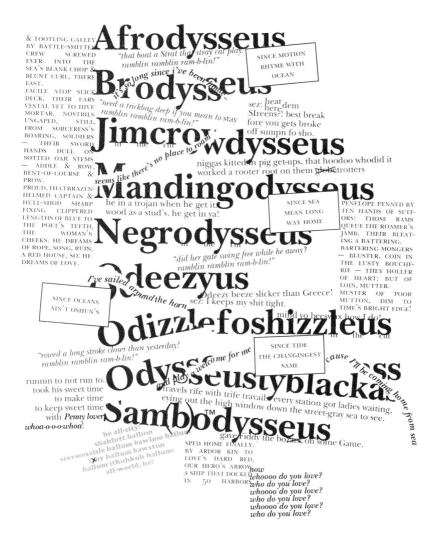

Afrodysseus
Brodysseus
Jimcrowdysseus
Mandingodysseus
Negrodysseus
Odeezyus
Odizzlefoshizzleus
Odysseustyblacka...ss
Sambodysseus™

& TOOTLING GALLEY
BY BATTLE-SMITTEN
CREW SCREWED
EVER INTO THE
SEA'S BLANK CHOP &
BLUNT CURL, THERE
FAST.
FACILE ATOP SLICK
DECK, THEIR EARS
VESTAL YET TO HIVE
MORTAR, NOSTRILS
UNGAPED, STILL,
FROM SORCERESS'S
BOARING, SOLDIERS
— THEIR SWORD
HANDS DULL ON
SOTTED OAR STEMS
— ADDLE & ROW
BENT-OF-COURSE &
PROW,
PROUD, THAT BRAZEN-
HELMED CAPTAIN &
HULL-SHOD SHARP
FIXING CLIPPERED
LENGTHS OF BLUE TO
THE POET'S TEETH,
THE WOMAN'S
CHEEKS. HE DREAMS
OF ROPE, SONG, RUIN,
A RED HOUSE, SO: HE
DREAMS OF LOVE.

"that boat a Strat that stray cat play. ramblin ramblin ram-b-lin!"

it's so long since i've been home

"need a trickbag deep if you mean to stay ramblin ramblin ram-b-lin!"

sez: hear dem SIreens?! best break fore you gets broke off sumpn fo sho.

in the cut

seems like there's no place to roam

niggas kitted in pig get-ups, that hoodoo whodid it worked a rooter root on them globetrotters

he in a trojan when he get it. wood as a stud's. he get in ya!

in the cut

"did her gate swing free while he away? ramblin ramblin ram-b-lin!"

I've sailed around the horn

Odeezy beeze slicker than Greece! sez: I keeps my shit tight.

mind yo beeswax how I do!

in the cut

"rowed a long stroke closer than yesterday! ramblin ramblin ram-b-lin!"

runnin to not run to. took his sweet time to make time to keep sweet time with *Penny lover* whoa-o-o-o-whoa!

and play's welcome me for me 'cause I'll be coming home from sea

travels rife with trife travails. every station got ladies waiting, eying out the high window down the street-gray sea to see.

he all-city: shahlutt hallum seerseesaisle hallum bawlmo hallum hey hallum bawstun hallum ithuhkuh hallum: all-world, he!

gave Fiddy the bozack on some Game.

SPED HOME FINALLY,
BY ARDOR KIN TO
LOVE'S HARD RED,
OUR HERO'S ARROW
A SHIP THAT DOCKED
IN 50 HARBORS

now
whoooo do you love?
who do you love?
whoooo do you love?
who do you love?
whoooo do you love?
who do you love?

PENELOPE PENNED BY
TEN HANDS OF SUIT-
ORS: THOSE RAMS
QUEUE THE ROAMER'S
JAMB, THEIR BLEAT-
ING A BATTERING.
BARTERING MONGERS
— BLUSTER, COIN IN
THE LUSTY BOUCHE-
RIE — THEY HOLLER
OF HEART; BUT OF
LOIN, MUTTER.
MUSTER OF POOR
MUTTON, DIM TO
TIME'S BRIGHT EDGE!

SINCE MOTION RHYME WITH OCEAN

SINCE SEA MEAN LONG WAY HOME

SINCE OCEANS AIN'T OSHUN'S

SINCE TIDE THE CHANGINGEST SAME

Three Thirsty Souls

Yusef Komunyakaa

Sometimes a man goes inside himself
 & rises in a damp sunny new land,
 Larry. Is this how you arrived

from Trenton Saturday mornings to sit
 in a Harlem library with Ralph,
 Romare & Albert vamping on ancient

stories, on color wheels & Webster's,
 down-home jazz & blues tonalities,
 folk & cosmopolitan plates of scat,

everything African from food to death?
 I envy those times now gone to dust
& easy fame. The old-school voyaged

from catfish to in the know. Larry,
 we sit here, tracing Romare
 from 401 South Graham Street

in Charlotte, to Pittsburgh, Harlem
 & St. Martin, crossing tributaries
 of country & blood, from *Lovers*

to *A Walk in Paradise Gardens*,
 from *Conjur Woman* to *Carolina*
 Shout, & then *Home to Ithaca*.

A place in the mind lives in the body,
 but they say no man is an island
 even if exiled in his weary bones,

returning with totem flag & insignia
 from an underworld of men
 pigheaded. Braced by a shield

& a javelin, Odysseus eases into the harbor,
 but he doesn't look like a seer or beggar
 driven by omens or a beckoning bow.

The raw breathing sound of a conch
 made the seagulls fly away as time
 washed over a Mediterranean green,

& now water can be heard lapping
 against the sighing wooden hull,
 the sails blown open by a salty wind.

Departure from Troy

Nathaniel Mackey

—"mu" one hundred ninth part—

So it was we came to red sky
country, flame red were flame
 red, blood red. Stylized fire
 flared
everywhere, red flame water-
 color brush tip, brush blood
 mixed with water. . . Rumor
 had
 it we were in Troy, leaving
 Troy. Stylized boats we
shoved off in. Sketchical fire.
 Blasé sun. . . Odyssean drift
 had
 hold of us, we thought we
were in Spain. "Red that I want
 you red," we sang, Circe's
 red
 couch and rug to be come
 to, blasé sun's why-not. . . We
 looked at the sky, we wondered
why red. The Greeks were back
 in
 Egypt and we were them. We
 had our pharaonic beards on,
black torso, throat, tongue. "Red
 that
 I want you red," we sang as we
rowed. . . Rooster-comb red. . . Won-
 dering why. . . Rooster-comb red
 we

took to mean wake up, war the
 big news no news. So it was or
so we'd have it, we the late exe-
 getes, we who'd been at it from
 back

when. Rooster-comb fire made
 shades of us, we the blutopic ac-
olytes, cartoon flames our friend
 it
 seemed it said, cartoon what con-
dolence there'd be. . . Egypt's out-
 ward mounting flare it might've
 been.
 Rooster-comb red nipped our
 backs as we hatted up, the sky
splotched red with a Petro paint-
brush, horsehairs left in a bowl of
 rain-
 water, said to've been a snake-
 headed brush. . . It was after the
end of the war but the war was every-
 where, rooster-comb red the color
 it
 all was, red what so bewitched
us, red was our delight. Wake up, it
 seemed it said, we never left, we
 were
 never there. Red meant we were
 meaning to leave. . . War droned on,
we nodded off. We dreamt roosters
 milled around us, the combs on
 their
heads came off, fire popped out of
 corners, crevices, cracks. "Red
 that I want you red," we sang,
 sad

galley sad gallery, rowed as we
 sang, come to where red was
all there was. . . Rooster-comb red
 enchantment. Phantom Troy. We

 were
 never there. . . Hair of the horse we
hid inside. Horse we made ashes of. . .
 Phantom Troy with we ourselves

 phan-
toms. To depart was to have never
 been there. . . Spooks boatlifted in
 from Amentet, we were gone again,

 there
 before we knew it, known only as

 we
 were
gone

A catechistic baton, a Stesichoric
 brush had our backs. The Greeks
 had never been there. There
 the
 North African Antilles, brush
blood water, blood siphoning
 water, to depart was to've not
 been
 there. . . Blue, green and gray,
 blue, green and lavender, the
change in the sea red's work. . . The
 change in the sea was us leaving.
 Roost-
 ers crowed all
 day

•

Red watercolor smoke it was
 filled up the sky. A flood
 of memory it seemed. Air
 we
 laid siege to, air we let go,
 upstart wind across an ibis's
 neck, air's anabatic blush. . .
 We
 were Africans in Greek dis-
 guise again, Greeks with
 a new paint job, Circe's old
 en-
 chantment an even older
 nonsonance, see-thru roust
 and redress. . . Red wasn't ap-
 pealing to what we knew for
 rati-
 fication. Red was telling us
 what we knew. . . A slow-motion
 glass cascade, broken glass,
 im-
 minent bout of tears held back
 Brooding the future, bearded el-
 dren's inequational redoubt,
 re-
 gret begun to be touched by
 light. . .
 Sun Ra showed up as we shoved
 off, U-Roy showed up, red-
 soaked paper the annuities of
 au-
 tumn, sun's why-not's what-
 next, I-Roy showed up. . . The
 Overghost Ourkestra blared in
 back

of us, had our backs, rooster-
 comb sonance whose bite was
astro-black, rasp a galactic static,
 sunspot boast our dispatch. . .
 A
 cataclysmic baton tapped us
on the backs of our necks. The
 change in the sea was us taking
 off. . .
 Taking leave we tore loose, plan-
etary debris, planetary drift. Mu we
 might've been, Earth opening
 up. . .
 We left. We put our pharaonic
beards on. It wasn't Spain we were
 in though we sang like Gypsies,
 the
 Pharaoh's black torso roughen-
 ing our throats, red that we wanted
 the red of the rooster's comb,
 rue waking up though we did. . .
 We
 were black Orpheuses, black
 Odysseans. We were trying to
 get home, trying to make heaven
 home.
 Home had a way of burning was
 red's awakening, home not home
 any-
 more

A kind of contained raving
came over us. We took our
 tongues out and threw them,
 we
 talked all out of our heads. . .
 Where eros began to be touched by
 elegy, anekphrastic splotch
 pox
red

Heritage
Adrian Matejka

after Bearden, DS (Death Series)

is lunchbreaking in the space between the last
rib & the back pocket of our hungry expectations.

Slick silver tie clip & white pocket square,
the morning sky like a crisp shirt. That's when

hunger's trigger finger squeezes every last bit
of hustle out of us like sunrise into a teacup

we aren't supposed to touch. The same cup
that sliced a finger to its cloud parts after cracking

on the parlor floor. Everything by hand, back then.
Before this dashiki throwback, before the backdrop

of all things leavened & creased by the Mississippi's
muddy bosom. The ribs underneath are now

scaffolding for afros & the neat halos of power
fists. A whole new hemisphere as bass heavy

& magnificent as the shadow of a woman dancing
in a headwrap & low-slung skirt. Now she's over

a glass table, fingering one nostril closed, the other
wide open to the gang of flies & tangled shine

tarnished by any genealogy we can make up.
Oxidizing the ancients. The simple history of hustle

& Jesus piece. Any boy with tributaries instead
of ribs will trade a warrior mask & antique swag

for a high-top fade & a place at the glass table.
Any boy slanting in a fitted cap, those tributaries

tangled in the imaginary gold around his neck will
drop like G's in gerunds for a new throwback.

Conjur Woman

E. Ethelbert Miller

She laughs with the birds before she talks to me.
Heartbreak lovin' brought me to these woods.
Yes, I'm sick and can't think right—you know I did wrong.

Every man has to find his road before his creek rise.
This woman knows you chase the sun and follow the moon.
She knows the world is black and white and filled with fools.

Conjur woman cures my eyes before I see the blues.

Tubman

E. Ethelbert Miller

Arm yourself, or harm yourself
—AMIRI BARAKA

Short woman with a gun
Leading me through woods InoS
Footprints left beside rivers

Freedom is a powerful thing
Sometimes you have to hold it
In your hands and listen

For the click

Among the Lotus-Eaters
Marilyn Nelson

An archipelago of atolls. Rings
of coral interfacing sea and sky.
Protective reef, deep pass, shallow lagoon
around the motu: hundreds of hues of blue!
Maidens hundreds of hues of brown offered
trays of their food: a flower called lotus,
that satisfies, yet increases hunger.
I sat down, asked myself why I should starve.

Eating a lotus flower, I knew my wife
had found another; my children were tall—
parents themselves, perhaps; my parents gone
to illness or forgetfulness or dust.
Must I go home? What *is* "home," anyway?
Should I consider one spot of green earth
more "mine" than all the rest of the planet?
Why not declare here "home," and take a swim?

Breathing the frangipani fragranced air
I feasted on lotus, and understood
how antlike are the lives of humankind,
how comic the havocked fixes we invent
to circumvent fate and the natural law.
Did Troy's fall make a nebula tremble?
Which of the seas was once Achilles's tears?
Whose children will recall my odyssey?

Stay, or return? What difference will it make
in the long-run metaphysathalon
between now and the looking-back future

if I stay here, feeling all human pain
through the god-eyed poetry of lotus,
or if—damn you, Odysseus!—you drag me
from the lotus-eater's distance-wisdom — memory
back to the sweat and spray of minute life?

Harriet Tubman
Geoffrey Philp

"When the sun comes back and the first quail
Calls," I'll be following you, Miss Harriet.

Following you and the Drinking Gourd.
In late winter through leaves of the quilted

Forest, alive with signs of our redemption.
I'm following you, my safe conductor,

Following you and that little old man
My station master, to "where the great big river

Meets the little river." For me and my fellow
Passengers on this glory train of psalms

Are heading into the valleys of Canaan.
And you won't need your gun, stuck in my ribs

Telling me, "You'll be free or die,"
"For the river bank makes a mighty good road,

The dead trees show the way."
Like the thousands more that you could have saved

If only they'd known they were slaves,
I'm following the Drinking Gourd, Miss Harriet,

Away from the magnolias that swing sweet
And low. "Lord, I'm going to hold on steady

And you got to see me through," for "I'll meet
You in the morning. I'm bound for the Promised Land."

Odysseus

Geoffrey Philp

It took a war and twenty years for me to see
These islands, spread like lotus pads across a lake,
That I love more than the murmur of my woman

Breathing my name, her hands resting carelessly
On my shoulder, and then, caressing the muscles
In my back that with each gentle thrust, quicken

Like the bow of my ship parting the waves
Like the way her skirt slipped off her thigh
That first night I slept without my sword.

But I knew long before I heard the songs
Of the those sisters, whose eyes were as dark
As the Aegean, that I could never find comfort

In these dull vineyards and olives trees on that far
Hill, whose rotting fruit remind me of the dead.
My home was always on the uncharted sea.

In the Realm of Shades

Geoffrey Philp

At first light, I was always awakened by new threat.
My trusted attendant held his blade to my throat,
And scraped away hair that would survive me.

My cook, who had clogged my veins with lard,
Spread the subtle poison of rumor.
I doubted the motives behind innocent gestures,

Fearing comrades I had counted as friends.
Every woman that I'd loved had betrayed me,
And after drafts of numbing wine, I repaid

The favor that led to more debauchery—
When I was no better than those dogs in the street
That licked the soles of beggars for a taste of salt.

Yet, in the midst of these flames that burn away lies
Has love delivered me from these torments?
I am blessed. I am blessed.

The Sirens' Song

Geoffrey Philp

Veins twisted by the sugar in my blood,
By wine I could no longer drink,

I pulled away the sheets to embrace my lover,
My friend, whose hair, like mine, was now pewter,

And squeezed the easy flesh around her waist.
Her memory had bound me to the mast —waves

When I plowed through the surf and listened
To the voices bubbling up from the ocean bed.

For I could always resist the subtle flattery
Of their songs, but never their laughter

That danced like light on the dark water,
Like the way their supple legs straddled the ribbed

Palms that grew from grinning skulls. Those sisters
Knew that for as long as I lived, they would never die.

Circe's Domain

Geoffrey Philp

The one-eyed dog barks at the moon
hiding behind dun clouds, while legions
armed with spears, torture crabs

and snakes for signs of their comrades
squealing in the mud. They claim it's magic
that's turned them into rutting swine,

but no amount of sorcery could have changed
them, except for their desire to see me
as something I never was, a goddess,

spring pure from the mind of a god
or the rib of some man. But all I had to do
was to show my legs to reveal their nature.

The Cattle of the Sun God

Geoffrey Philp

After so many nights sleeping with my sword
Across my knees, dreaming of wild boars,

I thought you would have heeded my word.
We had waded in the blood of our enemies

Waist high through Tartarus with two-faced
Tiresias, who warned us against our vice:

Hungry men obey the law of hunger.
But we are more than our bellies, my brothers.

More than the urge to savor the sizzle of meat
Or the moan of a woman under the sheets.

The wisdom of outlaws is known only by survivors,
But to have slaughtered these, beloved,

On the promise of forestalling doom by sacrifice,
You have blown out the light of your spirit.

A Nouveau Looks at a Bearden

Ishmael Reed

She keeps dragging me to these museums. Says that it's good for our image. That money is not enough. Says we have to show this old money crowd the Astors and the rest that we're as good as them. But, hell, that didn't work for Murdoch. He bought Laurance Rockefeller's apartment and paid three times as much as it's worth, but they still won't respect him. So I have to do this to please her. Hang out with these art weirdos. Fags. Charity Balls, art auctions at East Hampton estates, our pictures in the style section of the *Times*. Look at this one. By Romare Bearden. Now this painting shows the task we had. If our ancestors hadn't come here those mountains would have remained the same. We had to move these savages out of the way or else no progress would have been made. They did nothing to improve the land. These half-naked savages. Hunting animals with spears. All around them, nothing developed. The mountain looks like it's looked for a million years. Nothing changed. Nothing improved. These savages believed that you shouldn't take anything out of earth that couldn't be replaced. What primitive thinking. The earth is there to serve us not the other way around. *colonization* Hell, my company would have shaved that thing in half and mined the coal deposits. We cut down on labor with MTR. So what if Oklahoma has had 1,000 earthquakes because of fracking. That's the price you pay for progress.

We're saving lives by not sending men down in the mines and helping the country become independent from foreign oil. But do they appreciate it. Blame my company for hurting bio diversity and giving people cancer and respiratory ailments. Says we're fucking up the drinking water. A bunch of whiners. The takers are always criticizing the makers. But can they prove it? No. Just a lot of blather. Those professors we gave that grant to say that these eco freaks don't know the fuck what they are talking about. O, here she comes now. The guys at the club got on me about marrying a woman 40 years my junior. Hypocrites. Some of them have

women who are younger than that. Pay for their expensive apartments and condos and visit them while their wives are playing bridge. Boy does she look swell. That necklace from Tiffany's cost me a mint. That tiara, hair all fixed up, that Versace dress that I bought her. Just think. Three years ago she was serving coffee on Delta.

Bearden: Mask's Order of Riddle

Ed Roberson

Generations of features average to mask,
face whose any expression is recognizably
family almost by name pasted any

size sunk small from close to far time or cut out
brought closer than face to face, lined internal.
Challenging shifts in scale bark a familiar order

of riddle. What follows
who is what
are you? What more intralineal art to inquire:

Your scissored birds remind me sphinx have wings,
make clear why one explodes into dark flocks
at interrogatory sound, the rising tone

a scream; every appearance before it is
someone's fate fitting into place or not.
If one is not now the one of what proceeds from

here, one is not here. This is no killing.
The sphinx is wrongly accused and of simply
what is true. Those aren't bones, merely shadows

of the possible as yet incomplete;
another story where it is meet they live.
The slap of the exact moment to moment match

with what has happened to make will
happen is the ask of every breath
we answer, the rising tone,

in chorus often thought of half the time
as singing,
the rest, a chant round on a beaten skin.

Odd, for so fractured our rhythms,
you understand our consistency.

Mosaic

Tim Seibles

> I'm a'kickin' but not high,
> and I'm a'flappin' but I can't fly.
>
> —FLORENCE CHURCH

A carpet of light, the
ocean alive < half a moon
muting the stars.

I tell myself
despair is just

a bad attitude: *Get up*,
I say. *Look*—
and the shimmer

spends its name
in my head.

———

These days midlife
holds the jagged edge:

my nephew in prison,
a *prisoner* > friends insane

with work or sick
of trying be loved,

my parents handing over their lives
like evidence: my good mother,

her mind a trail of crumbs
in a woods flocked with birds.

--/--

To *raise* a child break it
like a wild horse—
bend the will: get up,
get dressed.

memory
 or repetition

I remember Emlen School
staring me down, my lunch box,
September:
the spiked fence freshly painted.

Then, the good-bye from my mother
who'd fought my hard hair,
lipstick like mist on my cheek.

--/--

That instant when eyes meet
and turn back—even love blinks,
looks off like a stranger.

With: Who are you
with? When you are with,

what's next?

--/--

I suspect *everything*.

Outside the air moves
a giant bird I cannot see.
I look hard > only trees
talking with chimes.

Still laced in this
brown body: my aging heart—
a-loom a-loomdoom—
still minds my thoughts,

but rolls his eyes.

———

To see <> to be seen: the life
of the visible. Don't be shy.

Glances pick my face.

~~Once, I was a sperm and an egg,~~
~~but no one saw me.~~

 --/--

Too small to walk
alone: I held

my father's index
finger. ~~Philadelphia police~~

~~caped in their black~~
~~jackets—big badges almost~~
~~hungry—looking~~ at us.

 --/--

In a mall: say a *food court*
on Saturday or a stadium
just before the game.

There's this drone, this
steady, muttering thrum

punctured by
packages—plastic this,
paper that—torn and torn.

"It's hard not to be hungry."

--/--

Time for bed: my
mother reading *The
Three Little Pigs*, doing
all the voices. Remember
the pictures—those piggy
pants and shirts?

--/--

When you *see me*,
what is that

image in the eye?
Solid ghosts, we are pictured
here—in the lit world.

Visible: we *want* to be seen: skin,
fancy legs shoes and hats.

To want > to be seen and
wanted. Nice lips with a moist

sheen. Eyes, like mouths.

———

What tortures, what tortures
me is the question: *what
are other people thinking?*

I keep watch—a vast horde
of *Nikes* has landed, running
like chickens neck and neck.

 --/--

In America skin was
where you belonged, a who

you were with, a reason

someone might: how—*at the*

parties of hands unknown—

astonishing deaths
could meet you.

 --/--

In Joy's arms, I believed
in perfect company, in the silk
of Her mouth—I believed:

my body off
the clock, my spine
all for touch,

my soul slightly
visible.

———

Four years old, I sang
like a chickadee. My father

slapped me for handing him
the scissors

wrong. What did I know?
What did I know?

--/--

Reckless eyeballs.

Three centuries track me,
their dumb dogs slobbering

on my scent: Myself turns

into my other self: *Over here!*

my self whispers—*Freedom
over here!*

--/--

Suppose nobody knows
what's
inside you.
But you, yourself,
find it pretty clear:

anxiety adding up, leveling off,
doubling some comfort in people
you think you understand frustration,

fatigue, a secret.
One worn constellation
marking the lusciousness of sex.

--/--

What's your faith? Which skin
do you believe? The *unseen*

stays with us:
the air

rubbing your lungs
right now—

the nations of germs
feuding over your hands.

--/--

Savory sweet salt of sweat in summer,
a taste of almonds, some buttery bread.

The loins, a house of hunger, personal
but not personal: the way moonlight calls

for you and not for you. What
I want > I guess < *I want.*

Fingernails grow. My
belly grumbles. My blood runs
up a long hill.

———

Among *the brothaz*, a certain
grip in the eyes. A sense
of something

swallowed not chewed—

as if they'd been made
a story and were dying

to untell themselves:
the streets—the prisons,
the sport inside the sports.

Outside, the wolf

with a
huff and a puff.

--/--

Culture: a kind of knife:
cuts one way opens
your brain to a certain
breed of light shaves
consciousness to its

purpose, its cross: the nail
thru your hand > your
other hand holding
the hammer.

--/--

Once, I asked my father
if he knew *everything*.

I was hopeful, seven—
a corn muffin
where my head shoulda been.

"Nah," he said, "Nope."

--/--

I only see
the game in pieces—
the rules inside me
like bad wiring < like a shadow
government < like dark
matter in a sky

otherwise Mardis Grased
with stars. Rise up,
somebody somebody

 --/--

(Insert your life here.)

 --/--

Did you mean to be this way?
Did you mean to become
something you didn't mean?

You didn' become
something you didn'
mean did you?

 --/--

Image follows image, quack follows
quack—a line of lonely ducks, What

is wrong is well
organized: see all the schedules
with their *Coors Lights* and comfy socks.

How do I look? With whom >< am I with?

Better worlds build hives
inside us. New words

trapped like wasps in our mouths.

 --/--

So monogamy never made
sense to me, nor most of what
was called *growing up.*

The whole
haunted house

of race and religion of sex,
money, possession.

Am I rented or owned?
How many lives turned
on the spit? How many
hours _____
and _____?

--/--

I was nine, integrating Anna
Blakiston Day School: fourth grade,

mixing it up. Visible,

with my soft face.
Whenever my mother had to meet
with the teachers, she'd say,

"Don't send me into battle
with a butter knife."

--/--

Connect this to that, *this*
to that: word by word, a
sentence

scavenges the alleys
like a lost pet—fur matted,
leg cut: the hunger,

a sort of riddle > his noise
some sort of answer.

What skinny faith you have—
and such big teeth.

All the better. I mean to step out
of history for just a minute,

to feel my blood float

above the *say-so*. ~~Memory,~~
~~a jar of flies.~~ Spin off the lid.

I forget what you know. What
did you ever know?

 --/--

To speak: score the alphabet—
make the shape of what

cannot be seen. Tear it open

like a child with a new bag
of something / stand in the traffic

goading your throat until the song
stomps out of your mouth—
the solo untamed,
that electric

uncertainty—one sound

chasing another.

 --/--

I think I'm
starting to know
Everything < O, tongue!
O summer! O, bold,
bare legs of women
upon which my soul beads
like sweat > O, rosemary rolls
and marmalade!
Hard-bodied beetles
with your six-legged sashay!
O,
funky beats and bitter
guitars < O, children
taller and taller no
matter
what!

O, moonlit sea! O, Hershey bars!
O, bizness besuited
pigeons of death: *How much
does it cost?* O, moment
flung from the last-last
to the next-next.

———

One dandelion head gone to seed,
half-flung on the wind.

I've sold a lot of myself already:
already alotta my selves been sold.

I have this feeling

every day—*something* I know
that can't

be words. This life

stuffs my eyes.

These people nearby—syllables

like pheasants flushed
from their mouths.

I'm back on my mother's lap
waving my small arms.

Coastal

Matthew Shenoda

I

The interest is in
the pull of desire

The way a pelican hovers
for a moment
before her dive

A rush of wind
and then, the plunge

In the paragon waters
sunlit sustenance in the glossy scales

And the gray yearning
an instance of music
and the silent reverberations
of the seal's paddle.

Risen, again, belly-full
to sail the sky above this ocean

If only men could understand
this ease

To resist their currency
in the murkiness of water

Wear their calico
with loose understanding

II

Every wind that enters
this coast
is a moment for want
to redefine itself
and make its home
with lingering

And on the shore
the women sing, praise and lament
pray the tide will bury the empty bellied vessels
to make their bows a home for sharks and plankton

To pull ashore the hulls of flesh and blood
rest them weary by the cook-pot
nourish them to remember their names

They call to the pelican above
to steer the mast to forgotten horizons
to lead these matelots to a home of their own
A place, perhaps just soft enough
That they will discover a love, however small
To keep them from stealing another's

circe / odysseus / black odysseys (a remix-collage)
Evie Shockley

for romare bearden and nina simone

i am black, but sorcerous i mean trouble gonna
put long uneasy miles between me and my home, but it's not
a one-way ticket this here's *circe's domain*—come on in and set a
spell hey, wanderer the north's no escape, just another stop
on some lonesome railroad line listen: rejection's telling
you to improvise *little girl blue* cotton-blue i do you this way,

 cause i can you bring your beast to my door,
 you're asking for trouble look: when i tell it, *the odyssey* is
 mine if the gods spew at you their red-eyed fury,

you might not ever find home harlem swings me a little
better philadelphia loves me some, brother carolina won't
stop me from shadowing my passion pierce me with your *other* spear—
the one that won't leave me bleeding you and me, we can pursue
things under these wide blue skies that will surely make
you forget about home i got the sea chasing me what can i
do but keep moving barbados aeaea st. maarten

 i follow the blue-black keys where they lead *be-bach!* o you
 ain't seen the full power of my mojo, baby who's
 lying to who believe me: my wand doubles as a sword

i swear: my voice is honey and venom picture ithaca i assemble
love from cut-up color, canvas and glue daddy, if a year is all
you got to give, give it here forever's a big blue illusion
anyhow see all the skulls marriage won't outlast freedom

 and liberia ain't the same as liberty tell me, how can
 i trust a woman with a snake for a bracelet well, it

don't mean a thing, if it ain't got that sting why should i
care about penelope if you don't if yellow if red if orange
if green if blue it's true: i'm dying to hear *the sirens' song*
you shape your future from your past the geometry of
don't can be transformed troubled women walking i
want *to bring forth a people* an outrageous magic shakes
me *everybody knows about mississippi* many men destroyed

i'm blue, but i won't be blue always never forget my pillow is
yours red sun shining against a full moon—night-noon's a sign,
right aix marks the spot one last stab at some kind of home
now go get back out there and do what you were born to do

Fixed on a Furious Star

Patricia Smith

1. *Passage.*

The passage begins with the sun an almost reachable want.
There is incredulous howl, the torpid sloshing of water against
wood. Imagine a woman, ankles slow with dust and blood,
her hair accidentally napped into impossible crown, breasts
low with friction and flow. She is crushed rigid against a bluing
man, his chest pushed into the crook of her knees, his flat back
hampering the breath of a child. From their days to these,
the lapping water is bleak twist, metronome. The vessel creaks,
rueful of the solid hum in its throat. The woman glorifies
the last rasp of someone. The baby stops just short of her own
machine. This is America, the new home. This glaring coax
is the conjured open arm. Look close, look. There. Look now.
And rejoice. No one has lied to them. The sun is the same sun.

2. *Auction.*

Our cries—ascending to ripple the work of the sky—are worth nothing;
what muscle we keep is the stuff of kings. My womb garners pennies,
my sister's left arm is a matter for discussion. It is decreed that my
mother's gray body can thrust no more usable commerce into the world.
His mouth pinned open, my brother's teeth are inspected like the teeth
of a horse. One incisor, blaring with rot, is probed and pulled loose
between a prospective buyer's pinched fingers. The blood pools in
the bowl of an eye. My father's flaccid penis is measured, recorded.
I am him in that moment, fist tied tight, his worth decided in inches.
My brother asks permission to spit his blood into the dust. Hearing its
cue, our one heart begins its runaway beat, its show for the nice people.
They clap crazily, the bidding roars. The heart is the first thing sold.

3. Instruction.

Yes. No. Lift. Go there. Fetch. Sweep,
Fuck. Breed, feed. Lie there. Now there. Marry
this. Not him. Bend. Push, carry. Wake up. Cook.
Pick. Don't. Don't ever. Shine. Leave here. Scrub.
Finish. Sleep now. Forget. Remember. Now, move.
Faster. Carry. Harder. Pick. Stop sweating. Drink.
Enough. Bring me. Cool me. Lie with me. Hard.
Don't speak. Boil this. Polish them. Carry. Push.
Hold this. Hold this still. Go get. That. No, that.
Take this back. Stand there. Make this. Close tight.
Too loud, much too soft. Saddle him. Sit down and
don't move. Now move. Not there, there. Now.
Call me master. Again. Be quiet. Don't scream,
don't ever. Scream. Never out loud. Not like that.

Odyssey's Crew or gods

4. Birth. Her.

A cluttered name is a song sung behind hands.
Your first lesson is not to arch toward touch,
but to suspect its motives.

5. Struck by the weight.

I knew what I was doing. I knew that the white man would
ask, that I would say no, that the slave would look past
us toward light, that the weight would miss him, hit me.
I knew that my blood threaded blaze into the sawdust on
the floor, that what I had come to buy would be scattered
around me, that no one, not one, would scream. I knew
what I was doing. I was killing myself a little. That man
split my head wide so that something wider could get in.

6. Unconscious.

I am not dead. Believe that. Dead would feel weaker than this.
Instead, my breath, reeking of coma, is unleashed weather in
my center. God nudges me in this mud light, stuttering instruction
that is secular and slant-rhymed, he makes no move to rouse me.
I am not anything dead. I hear my mother's spittled string of prayer,
her chained sisters ring my quilted palette, building communal
blood in wailed ballads. I hear the dwelling's wood swelling
in mourn. I hear the him, asking if I have spoken, eaten, if I will
soon be well enough to stand upright again in a field. God rocks
his robed hips to the hymns, touches my head, says furious/star.
I don't understand Him, but every day night takes hold in my legs.

7. She runs.

Run, Araminta. Break earth with your blind stride,
birth thunderous vowels. Run. Boldly unbending,
ghost child pounding a wrong song with God feet.
Throw your head back, become the everything
that nothing requires. Flagrantly disappearing,
All your self in motion, bones clacking, pulse
drumming staccato, all of you wild and rumble.
Except your eyes, solemn raging pinpoints, fixed.

black dogs bounce
pounce
black men crouch
renounce
spit all over
everywhere. whose
blood? whose
growl?
This up against the wall hurts. This
slap against the face strings. This
hate in your eyes saddens us. This

poison in you heats the air. This
always running makes us tired. This
big city seems not to know us. This
foot in our hair is wrong. This
country seems so small now. This
poem won't rhyme. And yes, this
gun is loaded.

8. *Free.*

What would it be like not to run? To simply stand
in one place and be welcome and acknowledged
there? How does it feel to stand still and be black?
Is there a life to be lived without an eye cast behind
you, looking to catch those who would have you?
To not run, to not bribe the wind. To not run, to
not know the first name of rivers, and animals.
To not run, to pass your days slow and with some
sort of reason. To be black. No, to be white. To
not run.

9. *Free*

God has crucified himself at the level of our eyes.
Do not pray to these buildings, the unclocked days,
to this walking without thought. Don't be fooled
into rendering this city Holy. Do not pray to the
absence of worry, to itching fields left behind,
to the gone dogs. Pray instead to the first slave.

10. *Free*

Realm of Shades

Tracy K. Smith

There was still a here, but that's not where we were, continually turning our backs to something unseen, speaking with just our eyes, getting on with work. What was our work? Our doors wouldn't lock. We rigged them, hung windows with sheets that broadcast our secrets after dark. People with weapons crept like thieves through their own houses. How did we feel? Like a canary cramped in a cage? Or the cat dying to know what the bird tastes like, swatting the rungs day after day, though the little hinged door never gives? No one hid. No one ran like a dog through the street. The moon traced its slow arc through the sky, drifting in and out of clouds that harbored nothing.

The Caged Bird Sings

Auntie Hoodoo Speaks

Sharan Strange

after Bearden, The Conjur Woman, *ca. 1977*

Every family's got at least one conjurer—it's true.
I'm a scapegoat when they're angry,
but when they're hurting, here they come
beating down my door. Many a pious Bible-
thumper's got a little sack with asafetida
and a wishbone tied with thread tucked in her bosom.
She's got a bowl of water under the bed.
I'm the subject of scuttlebutt, but when certain of
the Lord's mysteries need penetrating, when
he moves too slow, they seek me out.

You've got to know how to draw out
what's hidden in things. I ain't working
with nothing ain't already there. You can't
be afraid to claim a healer's right—to handle
the subtle energies, harness the forces of life
to your will. The snake bargains with gravity,
the physics of movement, as much as the bird. But it
covets paralysis, too, the efficacy of venom.
I don't mind being fearsome.

What I do they scorn me for, but only if it fails.
If they insist on probing the charred bundle before
burying it, if they can't stand the bitter rootstock, if
they ignore my reading of the signs, have I increased
their trouble? Or, did they, with their own fears, block
the path I've tried to clear?

This work is fraught with risk. What I do
ain't no trifle. I glean the secrets, the sins.

After the midwife and the preacher, there's me.
The difference is I'm the one they can lie about,
the one they visit only by the back door. Yet
I'm in between, really. A balancer. Hand to God,
hand to Mama. . . . I'm drawing on the sun and moon,
these fields, all these crawling and flying things,
plants, waters . . . everything speaking through me.

Something else I figured, testing this juju.
I'm outside of time just as much as I'm in this
time right now. What I mean is, connected to all the past
and responsible to the generations coming behind us.
Don't take this for pride, but I feel I deal in justice,
like those ancestors who fought so we wouldn't relinquish truth.
Not that I'm a Harriet Tubman, no, not such a mountain!
Some said she carried a gun, but think about it,
Miz Harriet had to have moved with intimate understanding
of the sublime workings of this world—and others, too, I believe.
I'm talking about sacrifice—summoning and giving shape to
a knowing that's not easy to fathom or control.
But I got sense enough to realize it ain't for me alone.
I'm simply bound to make it manifest, to whatever end Spirit intends.

Not that anyone's going to sing me into history.
You could say, though, I can make a way. . . . My place
is on the outside and at the center. I'm conducting in all
directions at once. My faith can't be puny. Not with this power.

Mythology

Natasha Trethewey

1. Nostos

Here is the dark night
of childhood—flickering

lamplight, odd shadows
on the walls—giant and flame

projected through the clear
frame of my father's voice.

Here is the past come back
as metaphor: my father, as if

to ease me into sleep, reciting
the trials of Odysseus. Always

he begins with the Cyclops,
light at the cave's mouth

bright as knowledge, the pilgrim
honing a pencil-sharp stake.

2. Questions Posed by the Dream

It's the old place on Jefferson Street
I've entered, a girl again, the house dark
and everyone sleeping—so quiet it seems

I'm alone. What can this mean now, more
than thirty years gone, to find myself
at the beginning of that long hallway

knowing, as I did then, what stands
at the other end? And why does the past
come back like this: looming, a human figure

formed—as if it had risen from the Gulf
—of the crushed shells that paved
our driveway, a sharp-edged creature

that could be conjured only by longing?
Why is it here blocking the dark passage
to my father's bookshelves, his many books?

3. Siren

In this dream I am driving
a car, strapped to my seat

like Odysseus to the mast,
my father calling to me

from the back—luring me
to a past that never was. This

is the treachery of nostalgia.
This is the moment before

a ship could crash onto the rocks,
the car's back wheels tip over

a cliff. Steering, I must be
the crew, my ears deaf

to the sound of my father's voice;
I must be the captive listener

cleaving to his words. I must be
singing this song to myself.

Romare Bearden's Art between 1964 & 1985
Quincy Troupe

1. Living in his memory

romare bearden rooted his artistic memory in mecklenburg county,
surrounded by cotton & tobacco fields, when he was three
his parents moved north from charlotte, north carolina to harlem where
he grew up—in pittsburgh too—listening to parents tell tall tales
of enchanting wide-eyed obeah women practicing mysterious african rituals, he
heard ancient practices of conjure, spells, the power of the laying on
of hands, forces emanating from people speaking in tongues, he heard black voices
booming in church choirs as they wove come-to-jesus magical incantations on
sundays, heard rhythms of syncopated jazz pulsating through summertime close
heat in uptown harlem, pittsburgh clubs, saw sardine-packed streets filled with
hipsters, women of the night, lizard-eyed pimps slithering through dusk, evening
shadows, "blues at the crossroads"
humid with pungent voices of singers moaning sweat & tears dripping
wet inside the slow drawl of speech old southern black people spoke inside
language, wrapping pretzel syllables succulent around words, heard
original phrases flowing rich tasting of shredded meat north carolina style, cleaved
from scorched bones of cows, pigs, saturated with spicy aromas
of barbecue sauce tickling noses with hints of hot pepper slathered over
the marrow of a long gone time & place rooted in mecklenburg county,
fast disappearing with the swift march of modernity's massive sweep
spreading its antiseptic culture of isolation, creating prisons
of fragmentation through buzzing nonverbal modes of speech communicating
via internet, speaking through texting after computers replaced pig-latin's mojo juju,
the gullah geechee southern hand jive clapping hambone styled linguistics, macking
down salt of the earth original sweet home idiomatic ways,
speaking through eye to eye human contact, feelings, instinct, gestures, absent
in a new generations homogenized grammar of politically correct speak,
in harlem romy grew up picking up snatches of old wordplays, conversations
overheard in his parents boudoir, his grandparents home during time spent
in pittsburgh hearing tales describing the place where he was born,

stories he felt familiar with as old black folks he met & loved, so he pad-locked these
folk images of a fast disappearing way of life soon come inside the vault
of his memory bank, to be used later when he began creating art
privileging these recollections (what bearden later called his "prevalence
of ritual," a redefining metaphor of who & what black people were), it was
a mythic memory echoing gauzy images of what truth *really* was over *factual histories*,
from here bearden sprung collages of maudell sleet, cutouts of conjure,
obeah women, from this idyllic magical space rooted now in his imagination
he evoked a dreamlike visual language that spoke directly to the spiritual essence of
black folks—other americans, too—of a time & place
connecting memories, their deep longing to what they *knew* was true,
metaphors recognized, loved, celebrated, singing in their own hearts

2. Rituals of sacraments Romare saw in the mirror

when romare looked into the mirror he saw other black folks faces too
in the image of himself staring back from the cut-glass, saw masks
there, tricksters, mugs of people sitting out on stumps, heard
musicians innovating music inside urban chaos—duke count—hip men
getting down with women doing the camel walk, walking the dog, the lindy
hop, the turkey trot, the cakewalk, trucking in the cotton club, the jitterbug,
the black buttom (a dance so nasty only initiates did it) singing wine-
spodee-o-dee drinking wine, through guitars he read poetry of langston hughes, the
fiction of jean toomer (later ralph waldo ellison, albert murray), though
it was brilliant colors he saw on streets he absorbed—bright reds, purples,
blues, oranges, greens, beiges up against browns, shades of black,
whites, grays—the colors jumped out from everywhere,
settled in his imagination, then leaped onto canvases, boards like dreams
he saw in his sleep, all was revelation for a former social worker,
a gift of sacrament giving back in an unchanging pattern, sacred rite he knew
was resonance, a deeply rooted mystery, echoes his eyes focused on
(beauty, "joy, defeat, victory, endurance" etched in those black faces
staring back at him from his mirror), the power also of his own steady gaze underneath
his ever present cap, or hat, he looked like a kindly old buddha,
nikita khrushchev, with his round bald large head
he had the stoic look of a solid block of granite,
though to black folks he was familiar as a favorite uncle creating portraits

celebrating their lives—they looked like snapshots in old family photo albums—
they saw themselves in his art as they were—good or bad—
in images he created, based on his own face he saw each morning
staring back naked when he looked into his own mirror

3. Cutouts Romare saw in the streets

when romy looked into his memory he saw bodies of black women there, sometimes
silhouetted in shadows, he portrayed them in cutouts
as if they were powerful spontaneous improvisations he heard in jazz rhythms—
fractured tempos pulled from traditional melodies—was what he imagined
when he ripped pages from magazines, papers, to create
splintered images, illusions he laid down on boards held together with glue,
cut up pages holding images of vanderzee pho-toes of a sweet moment
in a woman's boudoir, he scissored life magazine snapshots, scenes
from a gordon parks, photographs witnessed zipping around
new york city streets in the wee wee hours, he saw finely decked ladies
with slanted eyes cutting back at him like razors slicing through the dark, scissors
snipping off ends of slick conversations rendered in cutout collages slipping from lips
of musicians cutting up on wailing solos of lady day,
the president of pork-pie hats, cut away to coalman hawking,
sweet blowing johnny hodges's deep saxophone wail driving duke's band
through chaos everywhere, cutting sessions in harlem's minton's,
people hanging around outside, listening to snapping counts of tap-tapping metal
plates of baby laurence—heel to toe, toe to heel—out on sidewalks
of 118th street in front of minton's & the cecil hotel back in the heyday of bebop, bird &
diz, cutouts of ellington's band stomping train whistles down tracks, bopping
saxophones dipping up & down between trumpet blasts
following duke's piano runs jamming arpeggios tickling ivory keys of who baby don't
you know the undertones of this music cutting solos firing through wee inky hours of
vanderzee's harlem night photos, documenting spirit denizens
of the dark, images snapped & clipped of a couple dancing
straight out of a magazine, romy cutting up black & white images,
pasting them together with glue, he saw himself in these mirror mythos
in the reflections of these snip snip images, nightlife swirling around him
in a blizzard of surrealistic images of black folks with slanted open, wide eyes,
pork-pie hats slicing ace-deuce, cocked, couples out on floors cutting rugs

as music cooked, then simmered, laid back, laid down, rose up again
to rub up against crescendo, cutout rhythmic drops of thelonious sphere
monk in minton's, glittering piano runs of art tatum shimmering through
nights full of black folks decked out, slithering reptilian across asphalt
like bud powell's tiptoeing notes high-stepping along lenox
until the sun rose up hot as sex, sent shadows scurrying back into corners
where they slept until parties started all over again around midnight

4. The images Romare saw in St. Maarten & the Caribbean

in st. maarten romy saw naked women in the clear warm waters of the sea
inside his caribbean imagination, saw elliptical swirls of women
rising from blue green waters like dreams of black mermaids
to enter watercolors he was painting, now he looked at calm, bucolic scenes,
striking pink bougainvillea bushes, the large blinding golden coin of the sun rising
hot in february, vines snaking up outlining the painted yellow body
of a woman with bare nipples, a belly button over a bush of brown hair covering her
sweet, moist vagina, laid up against a twisting mass of shrubbery, weeds, close by at
the shoreline, two brown men wearing yellow straw hats
fished with nets, carried their catch from the clear-green blue water,
the color of eyes of some of those beautiful caribbean women
who lived nearby in the jumble of brown huts surrounded by green vegetation, replacing here
the black & white cutouts romy created in the big apple,
women walked here slowly—instead of fast—through verdant green
landscapes of his watercolors, surrounded by phosphorous blues,
clear whites, muted browns, stick-figure palm trees rising up
from light brown beaches, a bulbous blue cloud hovering overhead
instead of streetlights, with what at first glance looks to be an anteater's nose—
though it also resembles a crab's claw—what a miraculous change here,
a transformation, where rollicking lenox becomes the chaos of caribbean carnival in
romy's art, a wondrous celebration of stunning colors
teeming with beauty, a signature of his last witness & testament,
a vision he saw looking back into his eyes from his mirror in st. maarten,
when daylight began fading into the opaque moments of darkness

Spring 2013

Lyrae Van Clief–Stefanon

~~Think about color:~~ how
from the gladiolus of the sternum
it flows, a fall of cyan and perse
from its source, a cobalt glow above the right eye
of a figure in a painting

you love;
because you need to study something

else; how it seeps into
that eye; the deep
green it seems to tint his cheeks beneath

the black paint of his implied
skin; the figure beside him, crowned
brown black, areolas painted chartreuse,
a woman who seems drained, to drain with
her downward gaze, his jumbled thorax exposed,
behind him her finger pointed towards
the work's lined edge.

~~To rescue ourselves from each other with~~ tie-dye
~~T-shirts,~~ yarn tourniquets—.

What you don't need is just as important as
what you do need. The Norway maple
ashy gray with a chartreuse wash
not yet sprung into chartreuse bud
in mid-April sunshine
seemingly immoveable save

100

the slight slow sway near
the bulb-tipped ends of its thinnest branches
stands in anticipation of its own purple

unfurling. Another street
in another city explodes, knocks an old man down
with the blast, stops the race he'd not
quite finished. Limp
flags momentarily flare. A red wash
on the sidewalk, police in neon vests
unroll their yellow tape.

Milton Avenue Cyclops

Afaa Michael Weaver

It came down to this, that everything
went to his head, up from the corner
where the lights mixed with broken emissions
from stars to the glitter that made in the cement,
up between his ears where silence sleeps
with the dead until it became some magnificent
golden wax like the ark of our covenant
with this land we made but is breaking us.

Come with me and find my child, my lost son
is what his mama says when she gets wild
sparks in her eyes like the folks in the insane
asylum we called Crownsville, and he was gone
but not gone, found but not lost, all lit up
from way down below where his feet made
a peace woven between hallelujahs and amens,
the end of our need for back talk and churches.

Siren Songs at the Royal Theatre

Afaa Michael Weaver

The thin gleam of eyes over long, mean southern roads
became old Highway #1 heading past Lincoln memorials
to hallelujahs, the sweet bottoms of blueberry dumpling
rhythm and blues, or just blues all in the mahogany thighs
and soft bottoms of feet curled around lovers' necks, Jesus
lost in the break of sugarcane melted down to sweetness—

Girl, I'll never leave you if you let me in the door this time

Tales of who gave what to who and who took what from who
and who is who, who was who—all the infinite ways rain
comes into hearts that were promised some kind of sunshine,
and then the loud shout and sudden drop into silence, the way
a woman can take you when mahogany is a library of lives
women brought here, shaped, loved, contained, held close—

Girl, I'll never leave you if you let me in the door this time

If all the thieves in all the worlds night might come to be
lose the song that is the seed of the black woman, it will
be the Apocalypse no prophet seer ever seen, the seams
of air, the tongue turned to water, origin of oceans and seas,
the scratchy itch of fire igniting itself inside gold tinderboxes
to make themselves suns, all life's bright keys now failing us—

Girl, I'll never leave you if you let me in the door this time

Death Series
Afaa Michael Weaver

In that space where we become what we
were not, where our absence is a symphony
of what cannot be heard, impossible beauty
of silence, what we know as memory, the last
touch of what we knew as ourselves, secrets
love kept from us, like how long we will wait
for each other, or with what eyes we will learn
to see where there is no darkness and shadows
have no place, a space that is also in this space
as my heart is in yours, your spleen is mine—
secrets the priests have kept from us so time
will have its own domain, and not be undone
by our ambitions or our grave fears of leaving.

Stricture

Crystal Ann Williams

after Bearden, Conjur Woman, *1975*

Through the Live, Love, Laugh shop window
I sometimes watched Stella's gnarl of a body
shamble up the block, hunched-back black stick *bruja*,
angry white hair & kohl lined eyes swathed in teal, orange
& white—her smoke trained against gods & devils,
our imperceptible offenses, dragging her bag of skulls &
heather, crows circling & cawing like sorcerers overhead.
Her voice was the first real knowing I had
that among us something is terribly wrong—
her cursing & screech sound track, that snarl & howl
eating up everything in Greektown, leaves & lamb
& sweet syrup baklava. For some unspoken reason,
she wasn't shuttled off. & I wondered
the things we wonder about strangeness, the foreign body,
how it was when she bathed or slept or danced,
from whence it came & at night to which it went.
It's my fault, really. Had I been tending to matters
Live, Love, Laugh, I would have missed her raging that day,
how it happily smacked their laughter to a cold stop, the girl
dropping her pastry, father yanking son, the four
legs flung to flee, the small, sane glint & grin of it,
how she examined me—black irises soft & speaking
a new language, which opened in me something
which I still cannot name.
When she nodded & smirked, I nodded back.
In my hand is that moment, a 20-year old seed,
which I roll & roll & worry, wondering, what was that
language & when will its brutality bloom in me, black
bruja? Has it already bloomed in me?

Contributors

Chris Abani is the author of numerous books of poetry and prose, most recently *The Secret History of Las Vegas* (2014), *Sanctificum* (2010), and *There Are No Names for Red* (2010). He is the recipient of the PEN USA Freedom to Write Award, the Prince Claus Award, a Lannan Literary Fellowship, a California Book Award, a Hurston/Wright Legacy Award, a PEN Beyond Margins Award, the PEN/Hemingway Award, and a Guggenheim Fellowship. Born in Nigeria, he is currently Board of Trustees Professor of English at Northwestern University.

Elizabeth Alexander is a poet, essayist, playwright, and teacher born in New York City and raised in Washington, D.C. She has published numerous books of poems, including *American Sublime* (2005), which was one of three finalists for the Pulitzer Prize; a young adult collection (coauthored with Marilyn Nelson), *Miss Crandall's School for Young Ladies and Little Misses of Color*, which won a Connecticut Book Award in 2008; and, most recently, *Crave Radiance: New and Selected Poems 1990–2010*. She is Wun Tsun Tam Mellon Professor in the Humanities at Columbia University.

Cyrus Cassells is the author of a number of collections of poetry, including *The Mud Actor* (1982), winner of a National Poetry Series award; *Soul Make a Path through Shouting* (1994), which won the William Carlos Williams Award and was nominated for the Pulitzer Prize; *Beautiful Signor* (1997), which won a Lambda Literary Award; *More Than Peace and Cypresses* (2004); and *The Crossed-Out Swastika* (2012). Cassells has received a Lannan Literary Award, two NEA grants, and a Pushcart Prize. He is a professor of English at Texas State University–San Marcos and has served on the faculty of Cave Canem.

Fred D'Aguiar is a poet, novelist, playwright, and essayist. Born to Guyanese parents in London, he spent ten years in Guyana as a child. He wrote the film script of his first novel, *The Longest Memory,* for BBC Channel 4 television. He is the winner of the Whitbread First Novel award and the

David Higham Prize. His book of poetry *Continental Shelf* (2009) was a Poetry Book Society Summer Choice. His most recent publications include a poetry collection, *The Rose of Toulouse* (2013), and a novel, *Children of Paradise* (2014). He teaches at UCLA.

Kwame Dawes is the author of twenty collections of poetry and numerous books of fiction, criticism, and essays. Most recently, he is the author of *City of Bones* (TriQuarterly, 2017); editor of *A Bloom of Stones*, a trilingual anthology of Haitian poetry; and a coauthor (with the Australian poet John Kinsella) of *Speak from Here to There*. He is Glenna Luschei Editor-in-Chief of *Prairie Schooner* and Chancellor Professor of English at the University of Nebraska, as well as a faculty member of Pacific University's M.F.A. program, director of the African Poetry Book Fund, and artistic director of the Calabash International Literary Festival.

Toi Derricotte's books of poetry include *Tender*, winner of the 1998 Paterson Poetry Prize, *Captivity* (1989), and *Natural Birth* (1983). Her memoir, *The Black Notebooks*, won the Anisfield-Wolf Book Award for Nonfiction in 1998 and was a *New York Times* Notable Book of the Year. Her honors include two Pushcart Prizes and fellowships from the National Endowment for the Arts, the Guggenheim Foundation, and the Maryland State Arts Council. In 2012 Derricotte was named to the Board of Chancellors of the Academy of American Poets. She cofounded Cave Canem Foundation and is a professor of English at the University of Pittsburgh.

Rita Dove was the youngest person and the first African American ever named Poet Laureate of the United States (1993–95). She has won numerous awards, grants, fellowships, and honorary degrees, including the Pulitzer Prize for Poetry for her collection *Thomas and Beulah* in 1987. Dove has also published a collection of short stories, *Fifth Sunday* (1985), and a novel, *Through the Ivory Gate* (1992). Her other books include *Museum* (1983), *Mother Love* (1995), and *American Smooth* (2004). She is Commonwealth Professor of English at the University of Virginia in Charlottesville.

Camille T. Dungy is the author of *Trophic Cascade* (2017), *Smith Blue* (2011), *Suck on the Marrow* (2010), *What to Eat, What to Drink, What to Leave for Poison* (2006), and the essay collection *Guidebook to Relative Strangers* (2017). She edited the poetry anthology *Black Nature* (2009). Her

honors include the American Book Award, a silver medal in the California Book Awards, two Northern California Book Awards, two NAACP Image Award nominations, and a fellowship from the National Endowment for the Arts. She is a professor at Colorado State University.

Vievee Francis is the author of *Forest Primeval* (TriQuarterly), winner of a 2016 Hurston/Wright Legacy Award and the 2016 Kingsley Tufts Award. She is also author of *Horse in the Dark* (2012), winner of the Cave Canem Northwestern University Press Poetry Prize, and *Blue-Tail Fly* (2006). Her work has appeared in various journals and anthologies, including *Best American Poetry* for 2010, 2014, and 2017, and *Angles of Ascent: A Norton Anthology of Contemporary African American Poetry*. She was the recipient of the 2009 Rona Jaffe Foundation Writers' Award and the 2010 Kresge Artist Fellowship. A Cave Canem Fellow, she is currently an associate editor for *Callaloo*, faculty for the Pacific University Low-Residency M.F.A. program, and an associate professor of English in creative writing at Dartmouth College.

Nikki Giovanni is an American writer, commentator, activist, and educator. One of the world's most well-known African American poets, her work includes poetry anthologies, poetry recordings, and nonfiction essays; it covers topics ranging from race and social issues to children's literature. She has won numerous awards, including the Langston Hughes Medal and the NAACP Image Award, and was nominated for a Grammy Award. Additionally, she has been named as one of Oprah Winfrey's twenty-five Living Legends. She has taught at Queens College, Rutgers, and Ohio State and is currently a University Distinguished Professor at Virginia Tech.

Aracelis Girmay is the author of the poetry collections *Teeth* and *Kingdom Animalia*. *Teeth* was a winner of the GLCA New Writers Award. *Kingdom Animalia* won the Isabella Gardner Poetry Award and was a finalist for the National Book Critics Circle Award. Girmay has received fellowships and grants from the Whiting Foundation, the NEA, Cave Canem, and the Jerome Foundation, among others. Her most recent book, *the black maria*, was published in 2016. She teaches poetry at Hampshire College and in Drew University's low-residency M.F.A. program.

Terrance Hayes's most recent poetry collection is *How to Be Drawn* (2015). His previous collection, *Lighthead*, was the winner of the National Book

Award in 2010. Hayes is the recipient of MacArthur, Guggenheim, and National Endowment for the Arts fellowships. *Wind in a Box*, a Hurston/Wright Legacy Award finalist, was named one of the best books of 2006 by *Publishers Weekly*. Hayes was born in South Carolina. He taught for twelve years at Carnegie Mellon University before joining the faculty of the University of Pittsburgh in 2013.

Major Jackson is the author of four collections of poetry, most recently *Roll Deep* (2015). Jackson is a recipient of a Guggenheim Fellowship and a Pushcart Prize, among other honors. He is the Richard A. Dennis University Distinguished Professor of English at the University of Vermont and serves as the poetry editor of the *Harvard Review*.

Honorée Fanonne Jeffers is the author of four books of poetry. Her most recent, *The Glory Gets*, was published in 2015. She has received an award from the Rona Jaffe Foundation and fellowships from the American Antiquarian Society, the Bread Loaf Writers' Conference, the MacDowell Colony, and the Vermont Studio Center. A fiction writer as well, she was cited in "100 Other Distinguished Stories of 2008" in *The Best American Short Stories* (2009). Jeffers is a native southerner but now lives on the prairie, where she is an associate professor of English at the University of Oklahoma.

A. Van Jordan is the author of four poetry collections—*Rise, M-A-C-N-O-L-I-A, Quantum Lyrics*, and *The Cineaste*—and a chapbook, *The Homesteader*. Jordan has won a Whiting Award, an Anisfield-Wolf Book Award, and a Pushcart Prize, and he was included in the anthology *Best American Poetry 2013*. A recipient of a Guggenheim Fellowship, a United States Artists Fellowship, and the Lannan Literary Award in Poetry, he serves as Collegiate Professor of English at the University of Michigan.

Douglas Kearney's *Patter* (2014) was a finalist for the California Book Award in Poetry. *The Black Automaton* (2009) was a National Poetry Series selection. Most recently he is the author of *Someone Took They Tongues* (2016) and *MESS AND MESS AND* (2015). He has received a Whiting Award and residencies and fellowships, including Cave Canem and the Robert Rauschenberg Foundation. Two of his operas, *Suction* and *Crescent City*, have received grants from the MAP Fund. *Suction* has been pro-

duced internationally. Raised in Altadena, California, he teaches at CalArts in Santa Clarita.

Yusef Komunyakaa is the author of more than a dozen books of poetry, including *Thieves of Paradise* (1998), which was a finalist for the National Book Critics Circle Award, and *Neon Vernacular: New and Selected Poems* (1993), for which he received both the Pulitzer Prize and the Kingsley Tufts Poetry Award. He received the Ruth Lilly Poetry Prize for "extraordinary lifetime accomplishments" from the Poetry Foundation in 2001 and the Wallace Stevens Award from the Academy of American Poets in 2011. Born and raised in Louisiana, he is currently Distinguished Senior Poet in the Creative Writing Program at New York University.

Nathaniel Mackey is the author of ten poetry chapbooks, six books of poetry, and an ongoing prose work, *From a Broken Bottle Traces of Perfume Still Emanate*. He is also the editor of the literary magazine *Hambone*. His awards and honors include a Whiting Award in 1993, the National Book Award for *Splay Anthem* in 2006, an Artist's Grant from the Foundation for Contemporary Arts in 2007, a Guggenheim Fellowship in 2010, and the Bollingen Prize in 2015. He is Reynolds Price Professor of English at Duke University.

Adrian Matejka is the author of *The Devil's Garden* and *Mixology*. His third collection, *The Big Smoke*, was awarded the 2014 Anisfield-Wolf Book Award and was also a finalist for the 2013 National Book Award, the 2014 Hurston/Wright Legacy Award, and the 2014 Pulitzer Prize for poetry. He is the recipient of fellowships from the Guggenheim Foundation, the Lannan Foundation, and United States Artists. His new book of poems, *Map to the Stars*, was published in 2017. He is the Lilly Professor and Poet-in-Residence at Indiana University in Bloomington.

E. Ethelbert Miller is a literary activist. He is the board chairperson of the Institute for Policy Studies and a board member of the Writers Center. He is coeditor of *Poet Lore* magazine. He was director of the African American Resource Center at Howard University from 1974 to 2015, is the former chair of the Humanities Council of Washington, D.C., and a former core faculty member of the Bennington Writing Seminars at Bennington College. He is editor of several anthologies and author of

several collections of poetry and prose, including *The Collected Works of E. Ethelbert Miller* (2016).

Marilyn Nelson is a three-time finalist for the National Book Award. She is the author or translator of some twenty poetry books. Her book *How I Discovered Poetry* was named one of National Public Radio's best books of 2014. Of her many collections, *The Homeplace* won the Anisfield-Wolf Award in 1992, *The Fields of Praise: New and Selected Poems* won the Poets' Prize in 1998, and *Carver: A Life in Poems* and *A Wreath for Emmett Till* won *The Boston Globe*–Horn Book Award in 2001 and 2005, respectively. She is a chancellor of the Academy of American Poets and poet-in-residence at the Poets Corner at the Cathedral of St. John the Divine.

Geoffrey Philp is the author of the young adult novel *Garvey's Ghost*, and he is currently working on a collection of poems entitled *Letter from Marcus Garvey*. His work is represented in nearly every major anthology of Caribbean literature, and he is one of the few writers whose work has been published in both the *Oxford Book of Caribbean Short Stories* and the *Oxford Book of Caribbean Verse*. Philp teaches English at the InterAmerican Campus of Miami Dade College.

Ishmael Reed is the author of some thirty books, including *The Complete Muhammad Ali* (2015), the novel *Juice!* (2011), and *New and Collected Poems, 1964–2007* (2007). His seventh play, *The Final Version*, premiered at New York's Nuyorican Poets Café in 2013; the others are collected in *Ishmael Reed: The Plays* (2009). The editor of numerous magazines and fourteen anthologies, he also is a publisher, songwriter, public media commentator, and lecturer. He is the founder of the Before Columbus Foundation and PEN Oakland, nonprofit organizations run by writers for writers. Retired after teaching for more than thirty years at the University of California, Berkeley, he now teaches at the California College of the Arts. Among his awards are a MacArthur fellowship, National Book Award and Pulitzer Prize nominations, and a Lila Wallace–Reader's Digest Award. Named the 2008 Blues Songwriter of the Year from the West Coast Blues Hall of Fame, his collaborations with jazz musicians for the past forty years were also recognized by SFJazz Center with his appointment, from 2012 to 2016, as San Francisco's first Jazz Poet Laureate. His online international literary magazine, *Konch*, can be found at www.ishmaelreedpub.com.

Ed Roberson has published ten books of poetry. Born and raised in Pittsburgh, he is a recipient of the Poetry Society of America's Shelley Memorial Award, the Lila Wallace Writers' Award, and the Stephen E. Henderson Award for achievement in poetry. His books have been awarded the Iowa Poetry Prize, the National Poetry Competition Prize, the Lenore Marshall Poetry Prize, and the Kingsley Tufts Poetry Award. Until his recent retirement, Roberson was Distinguished Visiting Writer at Northwestern University.

Tim Seibles was born in Philadelphia. He has published several collections of poetry, including *Hurdy-Gurdy* (1992), *Hammerlock* (1999), *Buffalo Head Solos* (2008), and *Fast Animal* (2012), a finalist for the National Book Award. His poem "Allison Wolff" was included in *The Best American Poetry 2010* anthology. Tim has led workshops for the Cave Canem writers' retreat and for the Hurston/Wright Foundation. He teaches in the English department and M.F.A. in writing program of Old Dominion University in Virginia. He also teaches in the University of Southern Maine's low-residency Stonecoast M.F.A. program.

Matthew Shenoda's debut collection of poems, *Somewhere Else*, was named one of 2005's debut books of the year by *Poets & Writers* magazine and was the winner of a 2006 American Book Award. Shenoda is also the author of *Seasons of Lotus, Seasons of Bone* and, most recently, of *Tahrir Suite* (TriQuarterly), winner of the 2015 Arab American Book Award. Shenoda is Dean of Academic Diversity, Equity, and Inclusion and a professor of Creative Writing at Columbia College Chicago, and is a founding editor of the African Poetry Book Fund.

Born and raised in Nashville, Tennessee, poet **Evie Shockley** is the author of several collections of poetry, including *the new black* (2011) and *semiautomatic* (2017). Shockley is also the author of the critical volume *Renegade Poetics: Black Aesthetics and Formal Innovation in African American Poetry* (2011). Shockley's honors include the Holmes National Poetry Prize and Stephen E. Henderson Award for outstanding achievement in poetry. She is an associate professor of English at Rutgers University.

Patricia Smith is the author of eight critically acclaimed volumes of poetry, including *Incendiary Art* (TriQuarterly, 2017); *Blood Dazzler*, a finalist for

the National Book Award of 2008; *Teahouse of the Almighty*, a National Poetry Series selection; and *Shoulda Been Jimi Savannah*, winner of the Rebekah Johnson Bobbitt National Prize for Poetry from the Library of Congress in 2014, the Lenore Marshall Poetry Prize from the Academy of American Poets in 2013, and the Phillis Wheatley Award in Poetry. A professor at the College of Staten Island, CUNY, and a faculty member of the Sierra Nevada College M.F.A. program, she is also a Cave Canem faculty member.

Tracy K. Smith is the author of three acclaimed books of poetry, including *The Body's Question*, *Duende*, and, most recently, *Life on Mars*, winner of the Pulitzer Prize in 2012, a *New York Times* Notable Book, a *New York Times Book Review* Editors' Choice, and a *New Yorker*, *Library Journal*, and *Publishers Weekly* Best Book of the Year. Her memoir, *Ordinary Light* (2015), was nominated for the National Book Award. She is a professor of creative writing at Princeton University.

Sharan Strange's debut poetry collection, *Ash* (2001), was selected by Sonia Sanchez for the Barnard New Women Poets Prize. Her poems have been included in many anthologies, including *Angles of Ascent: A Norton Anthology of Contemporary African American Poetry* (2013). Cofounder of the Dark Room Collective, Strange served as a contributing and an advisory editor of *Callaloo*. She teaches creative writing at Spelman College in Atlanta.

Natasha Trethewey served two terms as the nineteenth Poet Laureate of the United States (2012–14). She is the author of four collections of poetry, *Domestic Work* (2000), *Bellocq's Ophelia* (2002), *Native Guard* (2006)—for which she was awarded the Pulitzer Prize—and, most recently, *Thrall* (2012). A fellow of the American Academy of Arts and Sciences, she joins the faculty of the English department at Northwestern University in 2017.

Quincy Troupe is the author of ten volumes of poetry, including *Transcircularities*, *Choruses*, *Avalanche*, *The Architecture of Language*, and *Errancities*. In addition to chronicling his friendship with Miles Davis in *Miles and Me* and writing *Miles: The Autobiography* (with Davis), Troupe has recently published children's books on Magic Johnson and Stevie Wonder.

Lyrae Van Clief–Stefanon's first collection of poems, *Black Swan*, won the Cave Canem Poetry Prize in 2001, and her second collection, *Open Interval*, was a finalist for the National Book Award in 2009. Her other publications include *Poems in Conversation and a Conversation,* a chapbook in collaboration with Elizabeth Alexander. She is currently at work on a third collection, *The Coal Tar Colors*. She is an associate professor of English at Cornell University.

Afaa Michael Weaver is the author of fifteen poetry collections, including *Spirit Boxing* (2017), *Timber and Prayer: The Indian Pond Poems, My Father's Geography, The Plum Flower Dance: Poems 1985 to 2005, The Government of Nature,* and *City of Eternal Spring.* In 2017, he retired from Simmons College and is now a member of the core faculty in Drew University's M.F.A. program in poetry and translation. Weaver's honors include an NEA fellowship, a Pew fellowship, a Pennsylvania Council on the Arts fellowship, the Kingsley Tufts Poetry Award, four Pushcart Prizes, and a Fulbright appointment to teach at National Taiwan University.

Raised in Detroit, Michigan, and Madrid, Spain, **Crystal Ann Williams** is the author of four collections of poems, most recently *Detroit as Barn,* finalist for the National Poetry Series, Cleveland State Open Book Prize, and the Maine Book Award. Her third collection, *Troubled Tongues,* received the Naomi Long Madgett Poetry Award and was a finalist for the Oregon Book Award, the Idaho Poetry Prize, and the Crab Orchard Poetry Prize. She is currently a professor of English at Bates College in Lewiston, Maine, where she is also a senior administrator.

*Book design, cover design, and
typesetting by Marianne Jankowski*

*Composed in Adobe Garamond Pro,
Kino, and Mrs. Eaves*

Printed and bound by Sheridan Books